Using your Digital SLR Camera

Prentice Hall
is an imprint of

PEARSON

Harlow, England • London • ... ong Kong
Tokyo • Seoul • Taipei • New ... ris • Milan

PEARSON EDUCATION LIMITED

Edinburgh Gate
Harlow CM20 2JE
Tel: +44 (0)1279 623623
Fax: +44 (0)1279 431059
Website: www.pearson.com/uk

First published in Great Britain in 2012

ISBN: 978-0-273-76110-5

British Library Cataloguing-in-Publication Data
A catalogue record for this book is available from the British Library

Library of Congress Cataloging-in-Publication Data
A catalog record for this book is available from the Library of Congress

10 9 8 7 6 5 4 3 2 1
15 14 13 12 11

Cover image used under licence from LeDo/Shutterstock.com
Designed by pentacorbig, High Wycombe
Typeset in 11/14pt ITC Stone Sans by 3
Printed and bound by Rotolito Lombarda, Italy

Using your Digital SLR Camera

Louis Benjamin

Dedication:

To Denise, Mom and Dad, with love.

Author's acknowledgements:

My first acknowledgement has to go to my parents, who have inspired me, fed my curiosity, and even supplied me with numerous cameras throughout my life – including my first single-lens reflex camera (a Hanimex Praktica Super TL) so many years ago.

Inspiration for parts of this book came from many friends, students and associates at the International Center of Photography (ICP) in New York, including Frank Franca, Andy French, Karen Marshall, Gabrielle Motola, Harvey Stein and Barry Stone. Bradly Treadaway of the Digital Media Lab gave me some very useful feedback on the video editing section. Per Gylfe and Eugene Foster always have my back. Teaching photography is one of the best ways to learn about it, and ICP is one of the best places to do both.

Thanks again to The Doctor, who makes good things happen. Steve Temblett, Robert Cottee and Laura Blake acted as mission control – they transformed a pile of Word documents and TIFF files into the polished product you're holding in your hands. It's a pleasure working with professionals like them.

Publisher's acknowledgements:

The publisher would like to thank the following for their kind permission to reproduce their photographs:

(Key: b-bottom; c-centre; l-left; r-right; t-top)

Lensbaby, LLC: Heather Jacks 87, Pearson Education Ltd: Julian Bajzert. Bahamas Tourist Office 69, 101, Julian Bajzert. Bahamas Tourist Office 69, 101, Martin Beddall 108b, Brand X Pictures. Photo 24 115bl, Brand X. Jupiterimages. Alamy 102r, Creatas 71l, 93r, 112br, Creatas 71l, 93r, 112br, Digital Stock 115tl, 115tr, Digital Vision 74, 78, 88, 110, 114t, 115br, 118c, 118r, Digital Vision 74, 78, 88, 110, 114t, 115br, 118c, 118r,

Contents at a glance

Use your digital SLR camera with confidence

Get to grips with using your camera with minimal time, fuss and bother.

In Simple Steps guides guarantee immediate results. They tell you everything you need to know on a specific application; from the most essential tasks to master, to every activity you'll want to accomplish, through to solving the most common problems you'll encounter.

Helpful features

To build your confidence and help you to get the most out of your camera, practical hints, tips and shortcuts feature on every page:

 ALERT: Explains and provides practical solutions to the most commonly encountered problems

 HOT TIP: Time and effort saving shortcuts

 SEE ALSO: Points you to other related tasks and information

 DID YOU KNOW? Additional features to explore

WHAT DOES THIS MEAN?
Jargon and technical terms explained in plain English

Practical. Simple. Fast.

Contents

2 Setting up your camera for shooting

3 Taking control of exposure

4 Working with light

7 Composing better images

8 Managing images in Lightroom

9 Editing and printing in Lightroom

10 Basic video editing

Top 10 Digital SLR Problems Solved

Top 10 Digital SLR Tips

Tip 1: Make your camera vanish

The famous photographer Diane Arbus once described the camera as 'recalcitrant' and talked about how you have to learn what it will do. The power and flexibility of the SLR system offer a lot of advantages, at the cost of complexity. Of course, you can set them on automatic and use them like a point-and-shoot, but getting the most out of your digital SLR (dSLR) comes from learning how to make the machine do your bidding without a lot of thought and distraction in the midst of shooting.

If this is your first digital SLR, you're likely to read magazines and hear from other photographers about how much better some other camera is. It's easy to get caught up in some fixation, where you're always thinking your camera is obsolete or insufficient. That's really not the case. The camera's performance is only one piece of the whole picture and no one ever looks at an image and says, 'Oh, I can't believe they shot that with a such-and-such.' The most important part is your vision, and the best camera is the one you're holding when you make the shot.

Once you internalise how your camera works and what certain key controls do, you can focus your attention on what you want to shoot and how you want to portray it. You'll worry a lot less about how to get the camera to do something, or about whether the camera will work at all, and make the best possible photos with your camera. When you reach that point, the camera won't literally vanish, but it won't dominate your shooting any more.

Tip 2: Take advantage of your dSLR

Most digital SLRs have a lot of automatic convenience features built into them, so it's easy to use them as if they're point-and-shoot cameras. But the reason for using an SLR is to take advantage of its advanced capabilities to create much higher-quality images. The list below describes some of the advantages of the digital SLR over typical point-and-shoot cameras.

- Better-quality images: Lower noise, better colour rendition and higher resolution.
- SLRs are more responsive: Faster shutter release, autofocus and zoom.
- Reflex design and optical viewfinder: Compose your images through the same lens used to shoot them.
- More direct control: Adjust focus, depth of field, aperture, shutter speed and other settings without going through layers of menus.
- Interchangeable lenses: Your choice of optics allows you to determine how the camera sees. Choose among wide-angle, normal, portrait, telephoto and even special-effects lenses.
- Broad range of accessories, including external flash.
- Live View: Available in some models, you have the option to compose your shots through the display on the back of the camera. Some displays even swing out and swivel, allowing you to shoot from extreme angles more easily.
- HD Video (with interchangeable lenses, and it's cheap compared with a high-end video camera).

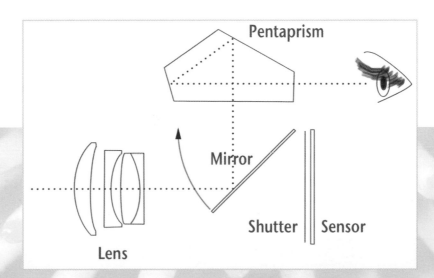

Tip 3: Buy the best 'glass' you can afford

Simply put, better lenses help you make better images. Admittedly, there are differences in image quality between basic and advanced digital cameras, so there is some advantage to spending more for a significantly better body. However, when you look at any image, the optical characteristics of the lens generally overshadow any effects of the camera's electronics.

Upgrading the cheap 'kit' lens that came with your camera can dramatically enhance your photos and expand your photographic options. One to three well-chosen, high-quality lenses will get you a lot further than a pile of cheap ones. The secret is in selecting the best lenses for the kind of shooting you mainly do.

Some potential advantages of better-quality lenses:

- Sharpness
- 'Faster' maximum apertures, e.g. f/1.2, f/1.4 or f/1.8
- Image stabilisation/vibration reduction
- Macro-focusing capability
- Choose among wide-angle, normal, telephoto and even special-effects lenses.

'Faster' lenses let in more light (allowing faster shutter speeds), while zoom lenses with continuous apertures don't get 'slower' as you zoom. With a fast lens, you can focus on a person's face and use a wide aperture such as f/1.8 to throw the background into a painterly out-of-focus pattern. 'Prime' (fixed focal length) lenses can be much lighter, faster, sharper and cheaper than zooms. Macro-focusing and wide-angle lenses allow you to work closer, while lighter lenses or image stabilisation can reduce the blurriness of hand-held shots.

Good 'glass' can be expensive, with some lenses costing substantially more than a body. But because SLR lenses are interchangeable, you can attach a great lens to any compatible camera bodies you may purchase in the future.

 HOT TIP: Cameras with 'full-frame' sensors offer dramatically better optical performance compared with cameras with 'cropped' sensors.

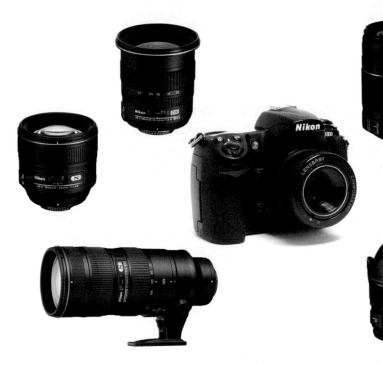

Tip 4: A great value lens: 50 mm *f*/1.8

Henri Cartier-Bresson, one of the most celebrated photographers ever, shot exclusively with a 50 mm lens on his 35 mm camera for most of his career. That focal length, when used on a full-frame camera such as the Nikon D700 or Canon 5D, is what is known as a 'normal' lens because its perspective nearly matches that of the human eye.

Fixed focal length lenses are also known as 'prime' lenses. While zoom lenses with a focal length range that includes 50 mm are very popular, the 50 mm *f*/1.8 prime has a lot to offer by comparison.

- The *f*/1.8 aperture will allow you to shoot in dimmer lighting conditions without flash or a tripod.
- The prime lens will be sharper. Some of the best (and most expensive) zooms come close, but the variable nature of zoom lenses means that sharpness will always be compromised a bit.
- The 50 mm lens is far lighter and more compact than a zoom. This makes it easier to store and carry the camera, and also makes it possible to successfully hand-hold the camera at the slower shutter speeds necessary for shooting in low light.
- Mid-range zooms are 'slower' and typically have maximum apertures of *f*/3.5–5.6.
- High-end zooms typically have maximum apertures of *f*/2.8.
- The 50 mm *f*/1.8 lens can be purchased for a tiny fraction of the cost of a zoom.

Most mid-range zooms also have variable maximum apertures, meaning that they become slower as you increase their focal length. Such a lens might be *f*/3.5 at 24 mm and *f*/5.6 at 120 mm. That's a loss of 1–⅓ stops over the range of the lens. To compensate, your shutter speed would have to decrease by more than half.

There are differences in the construction of different 50 mm lens designs. Some have plastic lens mounts, which should be avoided – you want one with a metal mount.

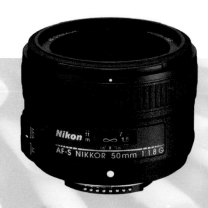

SEE ALSO: If your camera uses a cropped sensor, your 'normal' lens may be a 28 mm or 35 mm because of the sensor's focal length multiplier effect. See Chapter 5 for more details. You can read in depth about the relationship of aperture and shutter speed in Chapter 3.

Tip 5: Megapixels and myth

Megapixels have become shorthand for performance in digital cameras, when they're actually nothing more than a measure of the area of the image in pixels. The statistic is often bandied about the way horsepower is used to compare cars. However, all pixels are not created equal. In fact, cramming more megapixels into smaller sensors actually reduces the quality of the images they can produce. What megapixels do imply is the largest size you can print and maintain maximum quality. The print's resolution is an important factor in that quality.

- To double the size of an image, you need to increase the area (i.e. megapixels) fourfold. Thus, the difference between 10 and 12 megapixels is insignificant.
- You can also double the size by cutting the resolution in half.

At the industry-standard resolution of 300 dpi (dots per inch), an A4-size image is the largest print you can produce from any 10- to 16-megapixel camera, without resorting to resampling. At 300 dpi, an A3-size print requires at least an 18-megapixel image, and not even the 20+ megapixel images from top-of-the-line digital SLRs can make an A4-size print.

Printing photographs is somewhat more forgiving than text, so printing at 150 dpi can still produce very high-quality prints. At the lower resolution, 10–16-megapixel cameras can print up to A2-size and the 18–20+ megapixel cameras can make an A1-size print.

To estimate the 300 dpi print size of a digital camera, do the following calculation:

1. Take the square root of the megapixels.

2. Multiply the result by 10 to get the long dimension in centimetres, or by 4 to get inches.

3. Divide the long dimension by 1.5 to get the short dimension.

Thus, a 12-megapixel camera can produce a 34.64 × 23.09 cm print at 300 dpi. At 150 dpi, the dimensions work out to 69.28 × 46.19 cm.

Tip 6: The benefit of full-frame sensors

The majority of digital SLRs are based upon designs for 35 mm film cameras. The manufacturers replaced the film with a digital sensor and stuffed electronics into the body where the spools would have been. Initially, technical issues and production costs prevented them from producing sensors the same size as a frame of 35 mm film, and all digital cameras featured smaller 'cropped' sensors. But now a number of high-performance cameras are based on 'full-frame' sensors. Rather than cram the larger surface area of those sensors with more photosensitive pixels (known as photosites), most full-frame sensors have larger photosites and that results in the following substantial performance boosts.

- Increased sharpness: This is an optical phenomenon that cannot be imitated by digital means. On cropped sensors, the edges of the photosites cause refraction, which reduces the sharpness of the image.

- Lower noise overall: Even at the lowest ISO settings, full-frame sensors produce less noise. It comes in two forms: colour noise, which appears as random flecks of colour, and luminance noise, which are overly light or dark patches that make the image look grainy.

- High ISO performance: Images shot at ISO 6400 on some full-frame cameras are still sharp and display very little noise or noise-reduction artefacts. Cropped sensors tend to exhibit significant and unpleasant noise or effects of noise reduction somewhere around ISO 800. For a given f setting, 1/30s at ISO 800 and 1/120s at ISO 6400 will produce the same exposure. You can pretty easily hand-hold your camera at 1/120s, but you'll need a tripod to get a blur-free shot at 1/30s.

- No lens multiplier effect: Cropped sensors have the effect of increasing the focal length of your lenses, converting wide-angle lenses into normal lenses. With no cropping, your lenses work the same way they would on a film camera. That means your 35 mm wide-angle lens, a mainstay of street photography, works the way it did for greats like Garry Winogrand, instead of looking more like a 50 mm normal lens.

While the technical issues with full-frame sensors have been overcome, the cost of production is still upwards of 20 times that of a cropped sensor. As a result, cameras based on full-frame sensors are substantially more expensive. For example, Nikon's FX (full-frame) format D700 is nearly twice the price of the DX (cropped) format D300s. Both cameras appear to be built on the same magnesium chassis, but the area of the FX sensor is 2.3 times larger than that of the DX sensor. Given that both cameras produce 12-megapixel images, that means that the photosites on the FX sensor are approximately twice the size of those on the DX sensor.

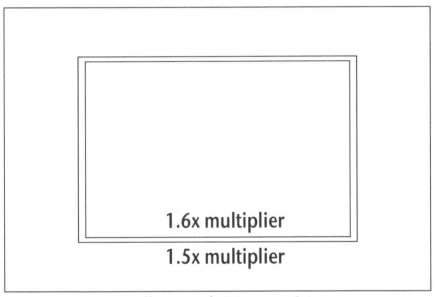

1.6x multiplier

1.5x multiplier

'Full-Frame' 36mm x 24mm

 HOT TIP: To determine the effective focal length of a lens, multiply its actual focal length by your camera's 'focal length multiplier' or 'crop factor'. For all Nikon DX cameras, that value is 1.5, making a 35mm lens effectively 50mm. For most Canons with cropped sensors, it's 1.6, so a 28mm lens is effectively 45mm and a 35mm is effectively 56mm.

Tip 7: Shoot in raw

Shooting in raw has a lot of advantages compared with shooting JPEGs. Even though raw files look as though they're photos, they're actually the digital equivalent of film that has been exposed but not developed. That means you can process the files with your computer, which has a much more powerful processor and more sophisticated software than your camera. When you shoot JPEGs, the raw data is processed in-camera to produce an image.

Raw files are read-only files that can be processed to generate images based upon the development settings you apply. While you can process film once and only once, you can process the raw file as many times and in as many ways as you like. You can even process a raw file twice or more and combine the different versions to produce a single composite with the best parts of each.

The biggest disadvantage of raw files is their size, compared with JPEGs. The JPEG version of an image can be one-tenth the size of a raw file from the same camera, but most current digital SLRs were designed to shoot raw files, so they are able to save the large files quickly. High-capacity memory cards and hard drives have also become relatively cheap. The current leading software for processing raw files are Adobe® Photoshop® Lightroom® 3 and Camera Raw 6 (a plug-in for Photoshop). Apple's Aperture 3 and Nik Software's Capture NX2 are low-cost alternatives worth considering.

Several other advantages to shooting in raw are listed below.

- All data is retained: The raw file contains everything that your camera recorded, while JPEG compression discards information to make smaller files. Even at the highest-quality settings, JPEG files have lost a substantial amount of information.
- Non-destructive workflow: When you process a raw file, the original is never altered. All adjustments can be revised as many times as you like.
- Exposure latitude: Raw files tolerate a greater degree of over- or underexposure than JPEG images.
- Override mistaken camera settings, such as white balance.

 HOT TIP: A lot of information on the Web about using raw is out of date. Many workflow and performance disadvantages have been overcome. Trial versions of all of the software mentioned above are available for download on the Web.

- You can convert a raw file to a 16-bit image, but JPEG images are always 8-bit. The 16-bit file offers a lot more latitude for tonal adjustments and can support much richer colours.
- Processing enhancements: Raw processing software sometimes improves and you can literally get better-looking images from the same raw files. This happened recently with the new '2010' processing 'engine' in Camera Raw and Lightroom.

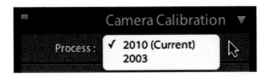

? DID YOU KNOW?

You can use the X-Rite ColorChecker Passport to make camera profiles that you apply under the Camera Calibration section of Camera Raw or the Lightroom Develop module. Camera profiles can dramatically enhance the fidelity of your images compared with the Adobe Standard camera profile.

Tip 8: Avoid auto white balance

White balance is designed to mimic the way our eyes adjust to the colour of light. If you shine a red light on a white handkerchief and ask someone what colour it is, they'll see a white handkerchief, but a camera without white balance compensation will 'see' and record it as red. White balance neutralises the colour of the light in a scene so that the camera interprets and records the colours without the influence of the light source.

When you use auto white balance, your camera tries to guess the colour of the light in the scene each time you press the shutter release. In some cases, the camera's guess may be good, but auto white balance can be fooled pretty easily, so the setting can vary widely from shot to shot. It's easy to end up with a set of shots of the same scene where several are far too blue, while others are too orange. To deal more effectively with white balance, it's better to select an appropriate, fixed white-balance setting for each lighting condition.

1. If you're shooting in raw, you can select a fixed white-balance setting (e.g. Cloudy) in your raw editor or in-camera.

2. You can dial in one of the manual colour temperature settings (e.g. 5600 K) in-camera or in your raw editor.

3. You can shoot a test frame with a grey card for use with the white balance dropper available in post-production software such as Lightroom and Aperture.

4. If you're shooting JPEG, it's crucial to get the white balance right when you shoot. JPEG has a lot less latitude for adjustment in post-production.

5. When shooting either JPEG or raw, you can measure a white balance preset with your camera and a neutral grey card.

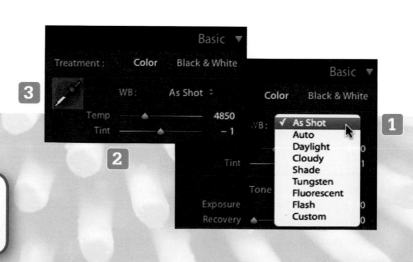

SEE ALSO: Setting and using white balance are discussed further in Chapters 2 and 4.

Tip 9: Avoid auto ISO

Auto ISO boosts the sensitivity of your camera so that you can shoot at a higher shutter speed when the light gets dim. The problem is that once your ISO goes above 800, you start to get significant digital noise or softening from noise reduction on cameras that do not have full-frame sensors.

Some cameras allow you to limit the maximum ISO that the camera will use when it's set to auto ISO so that you don't have to worry about the camera selecting an extremely high ISO and shooting a bunch of noise-filled images. However, it's generally better to select a fixed ISO and manually adjust it as needed.

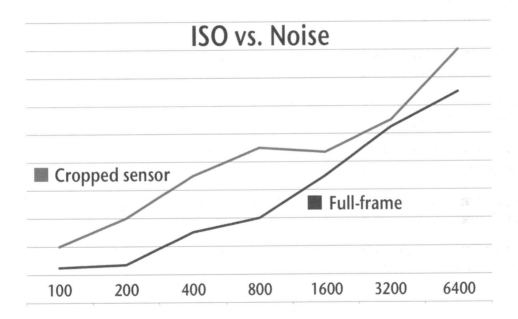

Tip 10: 'Photoshop' (editing) is not evil

It's pretty easy to find people who have bad things to say about 'Photoshopping' images. The problem isn't Photoshop, or even editing images with it; the problem is what some people do with it.

- In photojournalism, there is an ethical imperative not to alter the content of a photograph. Deleting elements or compositing things into the scene are as bad as staging a shot. The result is something that is not a true document.

- Some people argue that the rampant and often extreme retouching of advertising, fashion and even magazine cover images reinforces an impossible standard of beauty.

- Some amateur photographers have taken up blurring the skin to make their photos resemble the plastic look of some magazine photography. The result is something closer to a painting than a photograph, and often the resulting image barely looks like the person being depicted. That's more a problem of aesthetics than ethics, but it is unfortunate.

Personal work, creative photography and portraiture are not bound by the same standards or constraints. Using Photoshop to remove an embarrassing blemish, fix colour problems, enhance contrast, replace a blown-out sky or even create a composite are not bad things in the context of personal photography. In those cases, Photoshop is not evil, it's enabling.

Most of the things that people are doing with Photoshop have been done in the darkroom since the earliest days of photography, but only highly skilled practitioners were able to pull them off convincingly. Photoshop makes it a lot easier for the rest of us, but making quality work still takes a good eye and skilful technique.

1 Finding your way around the camera controls

Introduction

Digital SLR cameras are more flexible and sophisticated than their point-and-shoot cousins. Unfortunately, that flexibility adds complexity that can get in your way at the very moment you want to capture something compelling. You could set your camera on full automatic, but then you'd lose out on most of the benefit of using an SLR. Instead, you'll want to familiarise yourself with the features and controls that are most useful for you, so that you can get the camera to do what you want at the moment you need it.

This chapter will describe some of the more useful features available on most cameras in general terms. Because this book isn't limited to a few specific camera models, we have a bit of a challenge – different makes and models can vary dramatically in how they implement many features, so you'll need to get comfortable with your manual to achive maximum value from this book. In fact, it's a good idea to keep your camera and your manual handy as you read this book.

Read the manual – strategically

For most of us, reading the camera's manual is a daunting proposition. After all, manuals are often written in dry, technical language, and sometimes it's clear that they've been clumsily translated from some other language. Rather than read the manual from front to back like a novel, it's best to read it in bits, focusing on one part of the camera at a time.

Most manuals have a page or more with diagrams that label each of the camera controls. Bookmark those pages so you can return to them easily. You can use the diagrams as road maps to reading the rest of your manual. The terms in the diagram will have corresponding entries in the index. As you go through the remainder of this chapter, you can use the same diagrams to locate the features we are discussing.

You'll also want to take advantage of the manual's index directly. Terms such as depth of field preview are pretty much industry standard, so you're likely to be able to find those terms in the index, no matter what the make and model.

- When you see a lever or button on your camera that you don't understand, locate it on the diagram. Then use the diagram to identify the control and find the pages that explain it.
- Learn one feature at a time in this fashion.

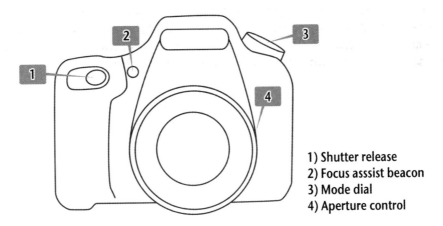

1) Shutter release
2) Focus asssist beacon
3) Mode dial
4) Aperture control

 HOT TIP: It's a good idea to carry your camera's manual with you, even after your initial orientation. It can be a handy reference in the field, and most are small enough to fit easily into a camera bag.

Navigate menus

Your camera's menu system is key to getting the most out of your camera. Like the various buttons on your camera, it's very helpful to learn how your menus are structured and how to navigate between them. You don't need to learn every menu command. Instead, figure out which menu commands you are most likely to use and remember how to get to those. It's especially useful to learn what kinds of functions are collected under each subgroup.

- Some cameras have two sets of menus – a simplified menu set, and a full-feature set. Useful functions such as file number sequencing may not be available in the simplified set. You'll want to know if there are two sets of menus and how to up-shift the menus (switching from the simplified menus to the full menu set) when you need to get to the more advanced features.

- Some menu items provide an alternative to button controls. For example, it's not unusual to find a button to set white balance on the camera body and still have a menu option for white balance. Other settings may be available only via the menus.

SHOOTING MENU

Set Picture Control
Manage Picture Control
Image quality
Image size
White balance
ISO sensitivity settings
Active D-Lighting
Color space

*Example menu items
from Nikon D90*

Exposure mode controls

Most cameras have a dial on the top panel to set the exposure mode. Auto-exposure modes use the camera's built-in light meter to control shutter speed, aperture, or both. Manual mode allows you to take full control of exposure for special conditions and creative options.

P – Program auto exposure: The camera selects both shutter speed and aperture (*f*-stop).

P* – Program shift mode: Once in P mode, many cameras have a dial to select alternative combinations of shutter and aperture (*f*-stop) which produce the same exposure. The display generally shows an asterisk to indicate that the default shutter and aperture settings are not selected.

A or Av – Aperture priority auto exposure: You select the *f*-stop and the camera selects the shutter speed. Your selection of aperture affects the depth of field in an image.

S or Tv – Shutter priority auto exposure: You select the shutter speed and the camera selects the aperture. Selecting a fast shutter speed (e.g. 1/125s and faster) can freeze motion, while slower shutter speeds can show moving objects as blurs.

A-DEP – Canon Automatic DEPth of field: The camera will choose an *f*-stop that allows all of the subjects to be in focus. It then selects the appropriate shutter speed for that aperture setting.

M – Manual exposure: You set shutter speed and aperture manually, using the exposure graph in the viewfinder to control how the photo is recorded. Use this primarily when you want to intentionally under- or overexpose your image.

 SEE ALSO: An alternative to using manual mode is exposure compensation, which is covered in Chapter 3. We'll also look in greater depth at exposure, shutter speed and aperture in Chapter 3.

 HOT TIP: Lensbabies and other lenses that cannot communicate with the camera are known as non-CPU lenses. Such lenses cannot be used with the Program or Aperture priority modes. For those lenses, you'll want to work in Manual mode.

Scene mode controls

Scene modes are special versions of the auto-exposure modes. They are tuned to emphasise some aspect of a scene by either freezing motion or controlling depth of field. If your camera has them, they are typically found on the same dial as the other exposure modes.

- Portrait: selects an aperture setting to produce softly focused backgrounds and then selects an appropriate shutter speed.
- Landscape: selects an aperture setting to increase depth of field, keeping both near and distant items in focus.
- Close-up (Macro): similar to portrait. It also creates softly focused backgrounds. Intended for close-up shots of flowers, insects and small objects. The camera automatically focuses on the object in the centre of the focus area. A tripod is highly recommended.
- Sports: selects faster shutter speeds to freeze action.
- Night Portrait: Portrait mode with the flash mode set to slow sync. It produces a more natural-looking balance between the subject and background lighting.

Macro Scene Mode icon

SEE ALSO: We'll look closely at how shutter speed relates to motion and aperture relates to depth of field in Chapter 3. Some prime applications of aperture and shutter speed are discussed in Chapters 6 and 7.

Metering modes

Look up either 'metering modes', 'matrix metering' or 'evaluative metering' in your camera's manual to locate the switch that controls this. Most cameras have three main modes: Matrix (Canon calls it Evaluative), Centre-weighted and Spot. You'll primarily want to use Matrix as that mode is smarter than the other modes and generally gets the exposure right.

- Matrix mode uses multiple sensors and a complex formula based on the Zone System to compute the proper exposure. It works really well.
- Centre-weighted and Spot metering measure smaller parts of the area covered by the viewfinder and use a much simpler method to calculate the exposure.
- Spot metering measures only about 1–5% of the area covered by the viewfinder.
- Centre-weighted metering emphasises approximately the central 60% of the area covered by the viewfinder.

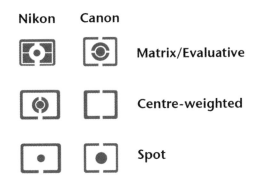

Nikon	Canon	
		Matrix/Evaluative
		Centre-weighted
		Spot

HOT TIP: Matrix metering is the go-to method for metering and it works perfectly most of the time. One situation where it gets the exposure wrong is when the subject is lit from behind or standing in front of a very bright background, which usually results in a silhouette effect. In those situations, you can use the Spot metering mode. Place the subject's face in the centre of the viewfinder and press the shutter halfway to lock in on the exposure, then recompose the scene and press the button the rest of the way to shoot.

What's in your viewfinder?

One of the advantages of the viewfinder in the SLR design is that you compose and focus the shot by looking through the same lens that the camera uses to make the exposure. Many cameras can be set to show a grid in the viewfinder as an aid to composition. Beyond that, the viewfinder is a heads-up display for how the camera is functioning – you can change settings and see them in the eyepiece.

Because a lot of information has to be crammed into a small area, the readouts are abbreviated. The illustration here shows examples of a 'No memory card' warning, central focus point, exposure indicator and battery indicator, along with a framing grid. Icons can vary significantly between camera models; you'll want to consult your camera's manual to make sense of the symbols inside your viewfinder.

On cameras equipped with Live View mode, you can compose with the screen on the rear panel instead of the viewfinder. In Live View, the camera's mirror locks up, shutting off the optical viewfinder. The readout includes video-related features and is arranged somewhat differently than the eyepiece display.

Just some of the information available in the viewfinder of most digital SLR cameras is listed below:

- shutter speed
- aperture (*f*-stop)
- ISO sensitivity
- exposure indicator
- remaining shots
- framing grid
- focus points
- focus lock indicator
- battery status
- 'No memory card' warning.

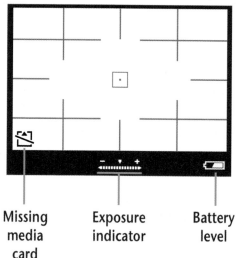

Missing media card Exposure indicator Battery level

 HOT TIP: It is good to know your camera's viewfinder coverage. Some cameras feature 100% coverage, but in other cameras the viewfinder shows only about 95% of the image that will be recorded. That means you aren't seeing everything that the camera will record when you shoot – the image frame will include additional space around the edges. The Live View feature is always able to show 100% coverage, regardless of the viewfinder coverage.

Use autofocus (AF) and focus lock

The controls and capabilities of AF systems vary widely among manufacturers and even between models within each manufacturer's lines. Your camera's AF sensors determine how quickly and effectively it focuses. A camera may have fewer than 10 or more than 50 AF sensors. Many cameras can be set so you can see which sensors are being used in the viewfinder.

The simplest way to use AF is when the subject is standing still. With the focus mode set to 'single shot', you can place the focus point on the part of the scene that you want in sharp focus, press the shutter button halfway to lock the focus, compose your image, then press the shutter button the rest of the way. The proposition becomes more complex when shooting moving scenes. Several controls work together to manage the sensors and how they are used.

- Some lenses have a focus mode switch. Select the Auto, A or M/A mode for autofocus.
- The camera body has a focus mode control. Single-shot (e.g. S or AF-S) mode is for still objects, while C, AF-C, AF-A, AI Servo and AI Focus are automatic modes designed for shooting in situations where the subject is moving.
- AF Mode Indicator: locate this feature on your camera. You'll want to know how your autofocus is set.
- AF Sensor mode switch: selects how many focus points to use and how the camera uses them. Single-point focus modes are best for still subjects, while dynamic modes can track focus with a moving subject.

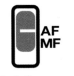

Camera body: AF Sensor controls

- AF Sensor selector: use it to select focus points via the viewfinder.
- AF sensor lock: prevents you from accidentally changing the selected AF sensor.

Lens: Autofocus mode

 HOT TIP: AF needs contrast to work. Some cameras have a focus assist light that comes on when the ambient light is dim. By default, your camera's metering system will also lock the exposure when the focus locks. You can change that setting if you wish.

Use autofocus with Live View

When shooting in Live View mode, dSLR cameras typically switch to an autofocus method called contrast detection. The method is slower than the phase-detect AF method described in the previous section and can have difficulty with fast-moving objects. Many manufacturers enhance contrast detection with face detection in Live View. These systems don't simply locate the face but do a good job of placing the point of sharpest focus on the eyes.

Some mid-range and high-end cameras have the option to use phase-detect AF in Live View. However, contrast detection is generally the default and is a much quieter autofocus method. Phase-detect AF is noisy because it needs the camera's mirror to drop down to focus and then pop back up to shoot.

AF-area mode

Live view/movie

Face-priority AF
Wide-area AF
Normal-area AF
Subject-tracking AF

*Example menu items
from Nikon D3100*

 DID YOU KNOW?

The Nikon D300 uses contrast detection in Live View when you switch to Tripod mode, otherwise it uses phase detection.

Single-shot and burst modes

When you set your camera to single-shot mode, it shoots only one frame each time you press the shutter button all the way down. When you switch to burst mode, the camera will continue to snap frames until you release the shutter button. This is helpful in situations where action is unfolding quickly (e.g. sports matches) because you can freeze a sequence of moments to get just the shot you want. It is also helpful to shoot short bursts when the shutter speed is relatively slow. Sometimes the camera shakes the moment you first press the shutter but will often be a lot more stable (and less blurry) by the second or third frame. The controls for these modes are sometimes on the camera body and sometimes accessible only via the menus.

04 Release mode

Single frame
Continuous
2s Self-timer
2s Delayed remote
Quick-response remote

*Example menu items
from Nikon D60*

Self-timer and intervalometer

The self-timer feature is handy for self-portraits, but not many people know that it is also useful when shooting in low light where a slow shutter speed and a tripod are required. Delaying the shutter release a few seconds is an alternative to using a remote trigger for the shutter. It allows any vibrations from pressing the shutter button to die down, resulting in a clearer image.

The location of the self-timer control varies a lot between camera models. For example, it's in the Drive menu on the Canon EOS 500D, but it's on a dial on the left side of the top panel on the Nikon D300. Consult your camera manual index to find out how to set the feature.

A related feature that is available on some cameras is an intervalometer or interval timer. The self-timer takes only one shot, but you use the intervalometer to specify a delay between shots for techniques such as time-lapse photography.

The self-timer feature is found in the Drive mode menu of Canon cameras

Review images

Most digital SLRs allow you to review your photos on the rear screen, either individually or in a grid of thumbnails. On some cameras, you hold a button and spin a thumb wheel to switch into the grid view. Once in the grid view, you can page between groups of images and select individual images. Look for the control that allows you to zoom in on a single image to check whether important elements are in focus, to see if someone blinked, etc.

You can cycle through the Histogram, Highlight Warning and other information displays for each image. The Histogram and Highlight Warning features can indicate when you might want to adjust your exposure and reshoot the scene.

Common controls on Nikon cameras:

 This button, combined with a thumb wheel, controls multi-image grid views and zooming in on individual images.

 Using the four-way rocker switch, you can:

- **navigate between images**
- **move around inside an image when zoomed in**
- **review the Histogram, Clipping warning, and other image data**
- **navigate menus and select menu items.**

Canon cameras use a rotating jog wheel instead of the four-way rocker.

 HOT TIP: You may need to use the menus to activate or configure the Histogram and Highlight Warning features. Most cameras have the option to show an aggregate histogram or a channel-by-channel display.

 SEE ALSO: We'll look more closely at exposure, the Histogram and the Highlight Warning options in Chapter 3.

2 Setting up your camera for shooting

Introduction

As you found your way around the controls in the previous chapter, you may well have taken some shots, but the prime purpose of that chapter was to point out the functionality of the camera. Before you shoot in earnest with your camera, there are a few housekeeping matters to address. These will help you shoot at the highest possible quality and keep track of your images once you shoot them.

Set image naming

As you shoot more and more photos, it becomes increasingly difficult to retrieve the photos you want. An important part of keeping track of your photos is maintaining unique names for them.

Most cameras name their files with a combination of a user-definable prefix and a sequence number. By managing the prefix and the way sequence numbers are assigned, you can be sure that every image you shoot has a unique name. Your prefix should also indicate which camera it came from, in case you shoot with more than one or replace one.

1 Switch on file number sequencing: Some cameras ship from the factory with this feature turned off. When it is off, your camera starts numbering your photos from 1 each time you reformat your media card. Switch it on so that your camera continues to assign the next number to each photo until it reaches some maximum value (e.g. 9999). Once it reaches that maximum, it will start at 1 again.

2 Use your camera's file-naming feature to assign a meaningful prefix: Most cameras have a separate menu option to set the prefix you want to use. By default, your camera will add a prefix such as DSC to the above-mentioned sequence number to create a file name such as DSC_5678. You can replace the generic prefix with one that uses two characters to designate the camera and one to designate how many times the sequence number has rolled over.

3 An example: You can use D1 and D2 to represent two cameras. A–Z can represent each run of the sequence numbers. If the first camera has shot 9999 images and has started over, its prefix would be set to D1B. The prefix D2A would represent a photo from the first round of sequence numbers on the second camera. When combined with the sequence numbers, camera 1 will eventually produce the files D1A_0099 and D1B_0099, while camera 2 will eventually produce the file D2A_1234.

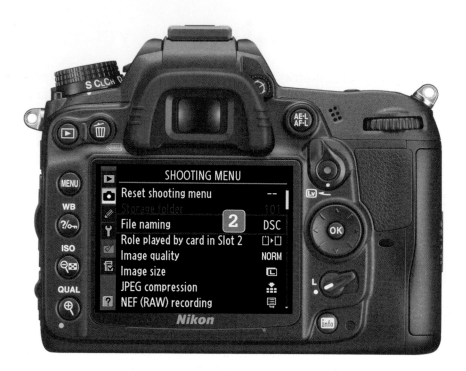

? DID YOU KNOW?

Beyond using the camera's naming capabilities, you can rename files as you download with utilities such as the import facility in Lightroom or Adobe Photo Downloader in Bridge. You can also rename files after they are downloaded. These topics are covered in Chapter 8 and in greater detail in *Editing, Storing & Sharing your Digital Photos in Simple Steps*, also by Louis Benjamin (Prentice Hall, 2011).

HOT TIP: Whether you rename your files or not, it's a good idea to have a naming and organisation strategy for the folders that will hold your image files.

Format your media card

Formatting your media card goes a step further than erasing all images on it. Your camera wipes the card completely clean and resets all the data structures on the card that will hold not only the image files themselves but also the metadata and file-management information that support them.

- Most cameras have a menu option to format the card.
- Many have a way to invoke formatting with buttons on the camera body.

SETUP MENU

CSM/Setup menu
Format memory card
Info display format
Auto shooting info
World time
LCD brightness
Video mode

Example menu items
from Nikon D40

! ALERT: When you transfer images from your media card to your computer, it's good practice to review the images to confirm they transferred OK and then reformat the media card in your camera. Do not use the option to automatically delete files at the end of the transfer, and do not use the computer to erase the contents of the card.

Select image quality – raw versus JPEG

Whenever possible, it's best to shoot raw files and use the more powerful software and CPU inside your computer to process them. JPEG files are small because your camera's on-board computer processes, compresses and even discards some of the data that the camera has recorded.

The raw format is more tolerant of exposure errors, and many important decisions, such as white balance, can be rethought as you process the file. This works because raw files retain every bit of data captured by your camera. They are the equivalent of film that has been exposed but not processed. Unlike film, though, you can process raw files as many times and in as many different ways as you like. The raw file format is read-only and all processing is done non-destructively. JPEG images have a lot less latitude for adjusting or correcting colour and tone in post-processing on your computer.

Another advantage of raw files is that they contain far more tonal information. The JPEG format holds only 8 bits per channel, meaning that each colour channel can have only 256 possible values. The raw format contains 16 bits (65,536 possible values) per channel. Editing images in 8 bits is prone to loss of shadow detail and banding – where smooth gradients break into stair steps of flat colour. 16-bit editing does not have that limitation. Raw processors such as Lightroom always work in 16-bit mode, and you can keep working in 16-bit mode if you transfer the file to Photoshop for additional editing.

For certain kinds of shooting, JPEG images have some limited advantages. They are ready to use and you can fit five times as many shots on the same memory card. For instance, if you are shooting photos of a party that will simply be uploaded to a website and never printed, then shooting in JPEG can save you a small amount of processing time, though you will probably want to make smaller versions for attaching to emails or uploading to the Web anyway. Most cameras let you select a JPEG quality level and it's best to use the highest quality (biggest file size) available. The lower quality settings produce smaller files, but they are also likely to show artefacts. Low-quality JPEG files have notorious compression artefacts. Images tend to look blurry and there is a loss of

detail. Often, specks appear around the edges of some parts of the image such as text and, in the worst cases, a tile pattern appears.

Though raw files look like images, they are not. Every camera has its own unique raw format and any software that edits or displays raw files has to catch up whenever a manufacturer releases a new model. That means Lightroom, Camera Raw, Aperture, Photoshop and even Windows and Mac OS have to be updated to display or edit the new format.

Image quality
NEF (RAW) + JPEG fine
NEF (RAW) + JPEG normal
NEF (RAW) + JPEG basic
NEF (RAW)
JPEG fine
JPEG normal
JPEG basic

Example menu items
from Nikon D7000

 HOT TIP: Most cameras allow you to shoot raw and JPEG files simultaneously, though the option fills up your media card faster. This is mainly as a convenience, since it's very easy to generate JPEGS in batches from most raw processing tools. Nikon raw files have a .NEF extension. If you have a Canon camera, the extension may be .CRW or .CR2. Other raw format extensions include .SRF, .SR2, .ARW, .PEF and .RAF.

Choose a colour space

In digital photos, RGB numbers specify what colours are supposed to appear within an image, but those numbers mean nothing by themselves. A colour space (also known as a colour profile) is used to define the specific colours represented by each set of colour numbers. Adobe RGB was designed to take advantage of colours that can be printed by high-performance photo printers, and defines a much larger set of colours than does sRGB. The much older sRGB standard essentially defines the lowest common denominator of colours available on most computer screens, which is why it is the standard for the Web. You may also encounter ProPhoto RGB, which is a high-performance colour space that defines substantially more colours than Adobe RGB. Each colour space has particular applications, advantages and disadvantages. For example, sRGB is not a good colour space to use for editing and ProPhoto RGB requires you to edit in 16-bit mode. You'll typically edit your images in either Adobe RGB or ProPhoto RGB, but you'll convert those images to sRGB for the Web and many other uses.

When you're shooting JPEG, your choice of colour space is important because it has an impact on how you have to handle the files afterwards. You'll choose either sRGB for simplicity or Adobe RGB for potentially richer colour when printing. Adobe RGB allows you to accurately print more of the colours in your image, even if your computer screen can't display them – standard computer screens can display sRGB colours only.

When you're shooting raw, the colour space you set in the camera is merely a suggestion. There's mainly one obscure technical reason to be concerned with your choice of colour space at all and that's so that the colours look right in the display on the back of the camera.

1 If you're shooting JPEG for the Web only (you don't plan to print), choose sRGB. Otherwise, you'll have to convert the files to sRGB before you upload them to the Web.

2 If you're shooting raw, your choice of colour space won't affect editing in Lightroom, Camera Raw or most other raw editors. And if you transfer the image to Photoshop or PaintShop Pro from the raw editor, you'll override the camera's colour space

HOT TIP: Check your printer driver's colour-management options. The key is to determine whether your printer or software can properly colour-manage Adobe RGB files. In some, you can't disable colour management; sRGB is probably best for those. Others can manage both sRGB and Adobe RGB. When Photoshop or Lightroom are managing the colours, you'll want to be able to turn off the printer's colour management. Good printer profiles are essential for the best colour performance.

setting with whatever you select in the external editing preferences or workflow settings of your raw editor.

3 Most cameras do not colour manage their display panel. When that is the case, Adobe RGB images will look pale and yellowish on them. Your images are fine and will display and print the correct colours in any environment that does proper colour management. When shooting in raw, you can set the colour space to sRGB to avoid this issue. The colour space setting applies only to the preview you're seeing on your camera.

4 If you're shooting JPEG and you want to print richer colours, Adobe RGB is a better choice, though the colours may not look right on the camera's display panel. Lightroom and Photoshop are two programs that can manage colour while printing.

5 When you want to make prints and the printer is managing the colour, sRGB is a safe bet, though some printers can also work with Adobe RGB. Many printing solutions (e.g. personal printers, kiosks and many printing vendors) are optimised for sRGB, but it's a good idea to check because you can get richer colour if the printer supports Adobe RGB.

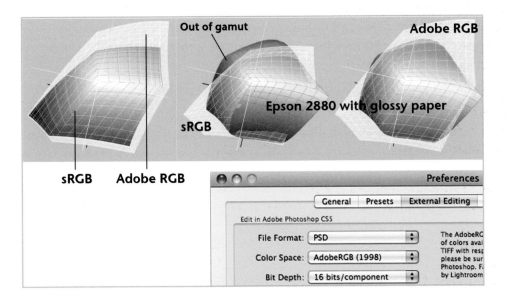

SEE ALSO: Transferring images from Lightroom to Photoshop is covered in Chapter 8.

Select ISO sensitivity

Aperture, shutter speed and ISO are bound together by a principle called 'The Sunny 16 Rule', which says that on a sunny day, you can set your aperture to f-16 and your shutter speed to 1/ISO (e.g. 1/100 for ISO 100) to produce a good exposure. Happily, all cameras these days have good built-in light meters because, regardless of ISO, the combination of aperture and shutter speed needed for a good exposure varies with the intensity of light.

A higher ISO (pronounced eye-ess-oh, not eye-so) setting can allow shutter speeds fast enough to handhold your camera in dim light or to freeze movement in brighter light. However, high ISO settings can also result in unacceptable digital noise or noise-reduction artefacts with cropped-format cameras such as the Canon Digital Rebel and the Nikon D90. Conversely, you can reduce the ISO to allow for aperture settings that allow for shallower depth of field or slower shutter speeds that produce intentional motion blur.

- A twofold change in ISO represents a 1-stop difference in sensitivity. Doubling the ISO has the same effect as reducing the shutter speed by half or opening the aperture one stop.
- Increase ISO to allow for faster shutter speeds or smaller apertures (higher f-numbers).
- On cropped-format cameras, digital noise begins to be a factor around ISO 800 and above.
- Full-frame cameras typically exhibit very little noise at ISO settings as high as ISO 3200 and can often achieve much higher sensitivities with acceptable noise levels.

SEE ALSO: We'll look more closely at the relationship between ISO, shutter speed and aperture in Chapter 3.

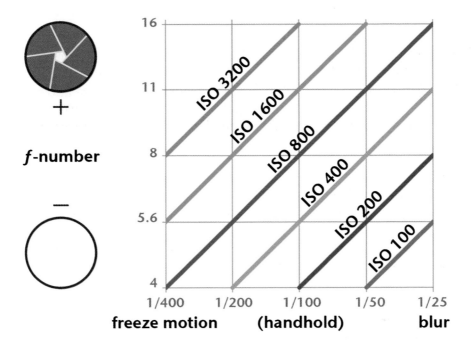

f-number

16
11
8
5.6
4

ISO 3200
ISO 1600
ISO 800
ISO 400
ISO 200
ISO 100

1/400 1/200 1/100 1/50 1/25

freeze motion **(handhold)** **blur**

HOT TIP: The illustration shows one example of how shutter and aperture settings might combine at different ISO settings for light that is considerably dimmer than midday sun. Read up from a shutter speed to an ISO line and then across to see the corresponding aperture for that ISO. You can also read across and down to find a shutter speed for a given aperture and ISO.

Select a white balance setting

Because our eyes adjust constantly, we're often unaware that light always has a colour. The white balance setting is designed to prevent your images from taking on a cast induced by that colour. It can also be used creatively, to intentionally add colour to your images. The trick is to recognise the colour characteristics of different light sources and what white balance setting they correspond to. Many cameras have a button on the body to change the white balance, while it is a menu option on others.

The colour of light sources typically varies between blue and amber. The colour temperature scale, which is expressed in Kelvins (not degrees Kelvin), is used to numerically represent each distinct colour of light. Amber and blue cancel each other out to produce a neutral colour, so white balance works by adding a counter-balancing amount of blue when the light is amber and adding amber when the light is blue.

To apply white balance creatively, use the tungsten setting on a sunny day to produce a golden colour cast and use the Sunny, Cloudy or Open shade setting indoors with tungsten lights to produce a blue cast.

The white balance settings in Lightroom and Camera Raw use the following colour temperature values:

1 Tungsten/incandescent (2850 K): These are common light bulbs with a filament. Halogen bulbs are also tungsten, though their colour temperature can be considerably higher than 3200 K.

2 Fluorescent (3800 K): These can be straight frosted tubes, rings or screw-in bulbs with a curly top. They are a special case because they usually emit a lot of green light that also has to be compensated for. White balance adds blue to neutralise the colour temperature and magenta to neutralise the green. The camera balances for 4000 K, but fluorescent bulbs are made with a wide range of colour temperatures.

3 Sunny/daylight (5500 K): This is a middle value for a bright sunny day. The camera adds amber.

4 Flash (5500 K): This can be the pop-up flash on the top of your camera or a speedlight that attaches to the camera. The camera adds amber.

5 Cloudy (6500 K): Cloud-filtered light is even bluer than bright sunlight. The camera adds amber.

6 Open shade (7500 K): If you stand on the shadow side of a building with open sky above you, you're in open shade. The light is extremely blue, so white balance adds the highest concentration of amber to compensate.

Back panel of the Canon 550D Rebel

 SEE ALSO: We'll look at additional techniques for working with white balance and colour temperature in Chapter 4.

 HOT TIP: If you are shooting raw, your choice of white balance isn't critical as you can remake your choice when you process the files. It is problematic to choose the wrong white balance when shooting JPEG. When in doubt, take a test shot and evaluate the results on your camera's display screen.

3 Taking control of exposure

Introduction

The exposure settings you choose (or that your camera chooses for you) determine how your camera will translate the light falling on the scene into a set of tonal values. It's a critical choice that cannot be undone, even when you shoot raw. Modern matrix metering does some sophisticated calculations to try to get the exposure right for you, but automatic exposure can only take you so far. Once you understand how your camera's meter works and the relationship between aperture, shutter speed and ISO sensitivity, you'll be able to make an informed choice about whether to let your camera do all the work, or to intervene and make creative choices about exposure.

The water model of exposure

An easy way to think about exposure is as though you are filling a container with light. The moment you open the shutter, light begins to pour into the camera. When you close the shutter and stop the flow of light precisely at the fill line, the result is a good exposure. If you close the shutter early, the container doesn't completely fill and the image is underexposed (dark). If you leave the shutter open above the fill line, the exposure overflows and the entire scene will eventually turn white if you leave the shutter open long enough.

The intensity of the light determines how quickly the exposure's fill line will be reached. When the light is bright, a lot of light flows from the source in a short time, like water from a fire hydrant. A moderately bright source might compare to a garden hose, and a dim light might compare to an eyedropper. In most cases, you won't have any control over the flow of light from the source, so you'll use shutter speed, aperture and ISO to adapt your camera to the lighting conditions.

- ISO controls the sensitivity of your camera and is analogous to the size of the container you want to fill. The higher the ISO, the smaller the container and the faster it will fill. If ISO 3200 compares to a shot glass, ISO 100 might be comparable to a 5-gallon bucket.

- Aperture, specified in *f*-numbers, controls how quickly light flows into the camera. The *f*-number is the denominator of a fraction, so larger *f*-numbers represent smaller apertures that allow less light. The aperture setting combines with the intensity of the light source to determine how much light flows into the camera within a given period of time. For example, at an aperture of *f*/5.6, enough light might flow into the camera in one second to make 30 ISO 100 exposures.

- The shutter speed is the amount of time between opening and closing the shutter. A shutter speed of 1/30 second would produce a correct exposure in the example just described. Increasing the shutter speed means decreasing the amount of time that the shutter remains open (making the shutter move faster), e.g. going from 1/30 s to 1/125 s.

● For any given lighting condition and ISO setting, there are several pairs of aperture and shutter speed that will produce a good exposure. This is because aperture and shutter speed counter-balance each other. Those pairings are called equivalent exposures and they are the basis of the Program Shift feature (part of the Program auto exposure mode), which we will discuss shortly.

? **DID YOU KNOW?**

Even though ISO is listed first, shutter speed and aperture are the main ways to control exposure. In most cases, you'll select a low to moderate ISO and change it only when special situations require it. Most digital cameras use a cropped sensor, which is smaller than a full frame of 35 mm film, and susceptible to digital noise at ISO settings above 800. If you are using a camera with a full-frame sensor, such as the Nikon D700 or Canon 5D, you will be able to use much higher ISO settings without digital noise problems.

Start thinking in stops

Table 3-1: The standard *f*-number scale in 1-stop increments

1.4	2	2.8	4	5.6	8	11	16	22

The essential unit of light in photography is the *f*-stop, or 'stop' for short. It is sometimes referred to as an EV, or exposure value, because it is a way of comparing exposures. A 1-stop difference between two settings represents a twofold change in the amount of light entering the camera, either doubling the light or cutting it in half.

Doubling the shutter speed produces a 1-stop decrease in the amount of light captured. Doubling the ISO increases the camera's sensitivity by 1 stop. It takes some time to learn the 1-stop increments of the aperture's *f*-numbers because they are based upon the geometry of its circular diaphragm. Still, the major divisions for aperture settings are 1 stop apart. For example, *f*/5.6 is one stop brighter than *f*/8.

Your options for setting ISO, aperture and shutter speed are all organised around 1-stop increments. On most cameras, the available settings are further subdivided, usually in ⅓- or ½-stop increments.

- Aperture and shutter speed balance each other. If you open the aperture 1 stop, you can double the shutter speed (a 1-stop change) to produce an equivalent exposure. In other words, *f*/8 at 1/60s produces the same exposure as *f*/5.6 at 1/125s.

- If your camera meter is showing that 1/30s at *f*/5.6 will produce a proper exposure and you want 1/125s at *f*/5.6, you'll need to increase the shutter speed by 2 stops. You can do that by increasing the ISO by 2 stops (double the ISO and then double it again). So, if you started with ISO 100, you can increase it to 400 to get the required shutter speed.

 HOT TIP: Equivalent exposures can look very different from each other because varying the shutter speed and the aperture affects the appearance of the photo in very different ways.

Use the auto-exposure modes

When your camera's metering system is set to Matrix or Evaluative mode, your camera's auto-exposure modes will do a very good job of determining a high-quality exposure in a broad range of lighting conditions. Program AE (P) is the simplest: set your camera to this mode and forget about everything. The fully automatic program decides both shutter and aperture for you. However, as you'll see later in this chapter, there will be times where you want more control.

There are reasons to intentionally select a shutter speed, aperture setting or both, according to their visual effect. The Program Shift, Aperture Priority and Shutter Priority modes are designed for some of those situations. They allow you to easily select among equivalent exposures, emphasising either shutter speed or *f*-number as needed.

- Program mode is fully automatic. Set it and forget it: the camera does all the work.
- Program Shift (P*) mode is an extension of the Program mode. Set your camera to Program mode, then select among equivalent exposures by turning a dial on the camera body.
- In Shutter Priority (S or Tv) mode, you spin a dial to set the shutter speed and the camera will select the appropriate aperture. If the necessary aperture is not available, you'll see a warning.
- In Aperture Priority (A or Av) mode, you spin a dial to select an *f*-number and the camera will select the appropriate shutter speed. It's a good idea to keep an eye on the shutter speed indicator when shooting in moderate to low light because it can drop below 1/60s. At the slower speeds, camera shake and motion can be problematic.

 HOT TIP: Scene modes are also auto-exposure modes. They are fully automatic modes tuned to prefer either shutter speed or aperture.

Take advantage of the aperture setting

Table 3-2: f-numbers in ⅓ stop intervals (full stops appear in bold)

1.4	1.6	1.8	**2**	2.2	2.5	**2.8**	3.2	3.5	**4**	4.5	5
5.6	6.3	7.1	**8**	9	10	**11**	13	14	**16**		

The classic aperture control is a ring on the body of the lens that changes the size of the aperture inside. However, some newer lens designs do away with the aperture ring, and you control the aperture via a wheel on the camera body. The phrases 'stopping down' (making the aperture smaller, increasing the f-number) and 'opening up' (decreasing the f-number) are commonly used to describe working with the aperture setting.

Even though the aperture works on the same principle of increasing or decreasing the amount of light by a factor of two, the f-numbers are based on the diameter of the aperture, so you can't determine the 1-stop intervals by multiplying or dividing by two. You'll want to memorise the sequence of aperture numbers that are 1 stop apart and commonly appear on digital SLR cameras listed earlier in this chapter. Most cameras also have intermediate ⅓- or ½-stop f-numbers – for example, f/3.2 and f/3.5 are at ⅓-stop intervals between f/2.8 and f/4.

Beyond exposure, the size of the aperture affects depth of field, which is the distance between the nearest and furthest objects that appear to be in sharp focus. Using a reduced depth of field is sometimes called selective focus, a useful compositional tool. A wide aperture (e.g. f/1.4) can produce a very shallow depth of field such that someone's eyes will be in sharp focus but their ears remain soft. Small apertures (e.g. f/16, f/22) can produce a depth of field where everything seems to be in focus. The effect of the aperture on depth of field becomes more apparent as the focal length gets longer. Wide-angle lenses (35 mm and wider) show a very mild depth of field effect. Normal to short telephoto lenses (50–105 mm) show a clear effect, and longer telephoto lenses (over 200 mm) have a pronounced effect.

If you want to change the aperture setting but not the shutter speed, you can adjust the ISO to produce an equivalent exposure. Increasing the ISO allows you to use a smaller aperture (e.g. f/16), while decreasing the ISO allows you to open up (e.g. f/2).

DID YOU KNOW?

The quality of the out-of-focus blur is called bokeh. Good bokeh is pleasing to the eye and not distracting. The quality of the bokeh is designed into the lens. Shallow-focus effects are not good with lenses that have bad bokeh, such as lenses that show harsh edges around out-of-focus highlights.

Take advantage of shutter speed

We generally think of a photograph as a representation of an instantaneous moment, but the shutter actually controls exposure by slicing off chunks of time. If the shutter opens and closes quickly, it can freeze motion by slicing a thin sliver of time. But if it stays open for a long time, moving objects can leave a ghostly trail or even vanish completely.

Using long exposures is sometimes referred to as 'dragging' the shutter, and these effects open up a range of creative opportunities. At shutter speeds of about 1/60 s or longer, movement or 'shake' can be a problem when hand-holding the camera. Heavier cameras and lenses may require even faster shutter speeds to avoid the blurry quality of shake.

You can change the shutter speed without changing the aperture by adjusting the ISO instead. You can do this to maintain the depth of field, or because you can't open the aperture any wider and still need a faster shutter speed. Just increase or decrease the ISO in proportion to the shutter speed. For example, doubling the shutter speed decreases the amount of light by 1 stop, and doubling the ISO offsets that by making the camera 1 stop more sensitive.

- When you need to make a long exposure, you can stabilise the camera with a monopod or tripod. Still, pressing the shutter button can cause the camera and tripod to shake momentarily. Gently squeeze the shutter release or, better still, use a remote shutter release.

- Camera shake can add subtle softness that looks like lack of focus long before it shows as obvious motion blur, particularly if you're doing macro photography. When you want really sharp photos with slow to moderate shutter speeds, use a tripod.

- You can also shoot short bursts when the shutter is slow – the camera may shake on the first frame or two but often becomes more stable by the third or fourth frame.

- You can use burst mode with a fast shutter speed (e.g. 1/500s) to capture several frozen frames per second. This can allow you to capture action at its most poignant moment.
- VR or IS lenses are effective and can allow you to hand-hold the camera at significantly slower shutter speeds than otherwise possible.
- If you don't have a tripod, you can brace yourself against a wall, a fence or some other firm object to minimise shake.

 HOT TIP: You can combine slow shutter speeds with flash for creative effects. Use slow sync to blend ambient light with flash. Or use the Rear Curtain or Slow Sync modes with a moving subject to mix frozen elements with motion trails. You can even intentionally shake or swing the camera to create dramatic trails.

WHAT DOES THIS MEAN?

VR (vibration reduction)/IS (image stabilisation): anti-shake feature which reduces the effect of camera movement.

High-key, mid-key and low-key

Your camera's idea of a good exposure is a balance of tones that gives an overall impression of moderate tonality – neither light nor dark. We call that mid-key lighting. It's great for general portraits and for documenting events and objects, but it's not an expressive tonal balance.

When the light gets dimmer, our eyes adjust, but we still recognise the scene as being darker. Many dramatic low-key images have only a small area that is brightly lit, such as the pool of light from a candle, while the rest of the image is extremely dark. The mood of low-key images can be sombre or mysterious. You may want to make the camera intentionally underexpose the scene to produce a more low-key image that matches the way you see it.

High-key images are often seen in fashion and beauty advertising and they are the opposite of low-key images. Such images contain mostly light tones and can even have some blown-out highlights. High-key doesn't necessarily mean that everything has a brighter exposure than it should. When you shoot a scene in snow, the camera will often record the scene in a way that renders the snow a shade of grey. To get the snow to appear white, you'll need to open up the exposure. Without at least a touch of solid black, such as the irises of the eyes in a portrait, high-key images can look washed-out.

Producing high-key or low-key images depends upon overriding what the camera thinks is a correct exposure. You can use exposure compensation with one of the auto-exposure modes or manual exposure to do so. For Manual-mode exposure, you'll want to get comfortable with the exposure indicator in your camera and you'll want to be familiar with the Histogram for any kind of exposure.

▶ **SEE ALSO:** We'll look more closely at the Histogram display later in this chapter.

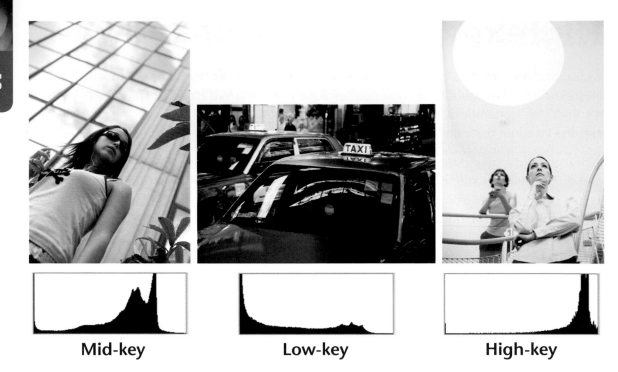

Mid-key **Low-key** **High-key**

Use exposure compensation

Exposure Compensation is an extension of the Program, Shutter Priority and Aperture Priority auto-exposure modes. You turn a dial to tell the camera to intentionally over- or underexpose the shot, relative to what it sees as the correct exposure. Overexpose to make your image lighter and underexpose to make it darker. You can usually adjust exposure compensation in increments of ⅓-stop.

Aside from using over- and underexposure to create high-key and low-key effects, you can use it to simply rein in the highlights and keep them from clipping when highlight detail is most important.

ALERT: Overexposing an image can blow out details in the highlights, while underexposing can block up details in the shadows. Completely blown or blocked details cannot be recovered, even with raw processing. When in doubt, bracket your exposures. You can also use the Histogram and Highlight Warning displays as a guide.

Bracket exposures

When the lighting is tricky, you can bracket your exposures as a means of insurance. Bracketing simply means instead of shooting a single exposure of the scene, you shoot two or more frames at different (not equivalent) exposures. For example, the light may be coming from behind your subject and you want to brighten the exposure to avoid silhouetting them, but you're not sure how much to overexpose.

You can use Exposure Compensation or shoot in Manual mode to create your brackets. Many cameras even have a Bracketed Exposure option that can manage your bracket settings. If your initial exposure is the default determined by your camera's meter, the bracket exposures will be over- or underexposed as needed. The exposure increment between brackets is up to you, but it's often useful to work in 1-stop increments.

Another application of bracketing is shooting for HDR (high dynamic range) images. In that case, you'll want to place your camera on a tripod and vary the shutter speed only to shoot your brackets. The idea is to capture some exposures that provide detail for the shadows, some which provide detail for the middle tones, and some which provide detail for the highlights. Typically, you'll shoot at least three exposures, but you can shoot more. When the light is very bright and contrasty, you'll want large increments between your brackets: they could be −2, 0 and +2.

Once you have your bracketed exposures, you can use Photoshop or other HDR-processing software to combine the tonal data from your shots and produce the combined image.

- In situations where you're concerned about losing your highlights, you might shoot your default exposure plus brackets at −1- and −2-stops.

- To open shadows, your bracketing could be +1- and +2-stops.

- The increments between brackets don't have to be the same, especially for HDR.

CUSTOM SETTING MENU

Custom setting bank
Reset custom settings
Autofocus
Metering/exposure
Timers/AE lock
Shooting/display
Bracketing/flash
Controls

*Example menu items
from Nikon D300*

Read the Histogram

The Histogram is a display that can help you make better exposures. It shows the distribution of tones in your image, using a series of vertical bars. You can bring the Histogram up on your camera's screen next to your image when you review it. You may have to use the menus to switch on the Histogram feature.

The shape of the Histogram indicates how light or dark the image is and whether any detail may be missing from the highlights or shadows. As you saw earlier in this chapter, a mid-key image tends to have a single peak clumped towards the centre, or two peaks on either side of the centre. A low-key image will have the tones clustered on the left, while a high-key image will have them clustered on the right.

When highlights are blown or shadows are blocked, the rightmost or leftmost edges of the Histogram will show either a spike or a vertical wall. Blocked shadows and blown highlights are known collectively as clipping. In high-key or low-key images, any clipping indicated by the Histogram is likely to be fine. If you are photographing something shiny, you may also see a normal spike on the right side of the graph. But in other cases, you may have lost important detail. Clipping is not something you can fix in raw processing afterwards, because there is no data available. If your histogram is showing issues with highlights or shadows, you can adjust your exposure and reshoot. Increase your exposure to open shadows or decrease it to avoid blowing the highlights. Of course, in high-contrast situations, you may find that you can have detail in the shadows or the highlights, but not both.

Most cameras also allow you to turn on a secondary option that addresses a subtle problem that can occur when only one or two of the colour channels in the image clip. You can set the display so that it shows the individual colour channel histograms and not just the aggregate.

Clipping

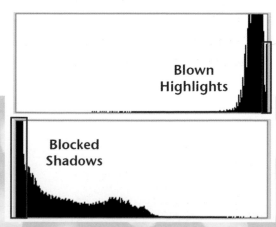

Blown Highlights

Blocked Shadows

 HOT TIP: Most cameras have a Highlight Warning option that you can use in addition to the Histogram when you're reviewing images. That option makes the blown areas of an image blink.

Use manual exposure

All of the auto-exposure modes link the aperture and shutter speed so that changing one setting changes the other. Those modes are designed to produce good mid-key exposures in moderate light. If you're shooting for HDR processing, you want to use exposure creatively, or you have a complicated lighting situation, the manual exposure mode is often the best way to go. The idea of using manual exposure can be scary, but it offers the advantage of direct control over your exposure, with tactile and visual feedback.

As you adjust the shutter and aperture settings, the exposure display in the viewfinder will show you how your settings compare to the exposure calculated by the meter. You just turn the appropriate dial until the meter indicates the exposure that you want. The centre mark on the meter scale is the same exposure that the camera would have assigned in one of the auto-exposure modes. You can also use the exposure display to intentionally over- or underexpose the shot for high-key or low-key effects. In back-lit situations, the meter will tell you when you've opened up an extra stop or so to keep the subject from turning into a silhouette. Most readouts cover a range of plus or minus two stops in ⅓-stop increments, but once you know the exposure value you can calculate the value needed to exceed 2 stops.

Lensbaby, Schneider, Zeiss and several other makers produce manual-focus lenses that can be used with Nikon- and Canon-mount cameras. These lenses are called non-CPU lenses because they do not contain electronics to send aperture, focal length and other lens-related data to the camera. Without that data, the camera's advanced metering systems cannot work, though averaging and spot metering are still available on some camera models. However, other cameras simply switch off their metering systems altogether.

If your camera's built-in metering is not available, you can use a hand-held light meter to determine the appropriate shutter speed and aperture. Hand-held meters are also very useful in more challenging lighting situations. For example, most hand-held meters can work in much dimmer light than a camera's meter. You can simply set the camera to manual mode and dial in the readings from the meter.

Here are some methods of working with manual exposure:

- For HDR images, use the shutter speed only to make bracketed exposures. You'll often want to make exposures that are more than two over or under the indicated exposure value. Double the shutter speed or divide by two for a 1-stop increase or decrease.
- You can set the shutter speed on the body of the camera first and read the camera's exposure display as you adjust the aperture.
- You can set the aperture first and watch the display as you adjust the shutter speed.
- Most Lensbabies use interchangeable aperture disks instead of a bladed aperture diaphragm. You can select an aperture first and set the shutter speed with the built-in meter, or you can use a hand-held meter to determine which aperture disc to use and dial in the appropriate shutter speed.

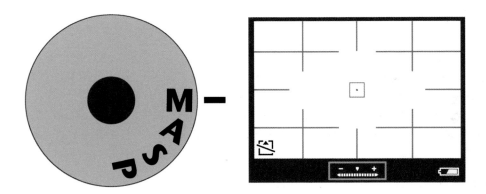

 HOT TIP: When you first switch to Manual mode, you may not know which way to turn the controls to see the meter move. You can briefly switch to one of the auto-exposure modes to see the suggested aperture and shutter speed settings. You can match your Manual mode settings to those values and then adjust them further, as necessary.

4 Working with light

Introduction

Aside from being the energy source that makes photography (which literally means writing with light) possible, light can take on several distinct qualities. We'll have a look at some of those qualities in this chapter.

Types of light: colour temperature and white balance

The colour of light primarily ranges in hue between amber (e.g. candle light) and blue (like the sky). Each of those hues is indexed along the colour temperature scale, with amber at the lower end of the scale and blue at the higher end. It's called colour temperature because of a principle in physics that relates colours to temperature readings: if you were to heat an object called a black body to a specific temperature, it would glow at a specific colour. The beauty of this system is that it allows you to precisely express a colour as a simple number.

If you're familiar with the terms 'warm colours' and 'cool colours' from graphic design, those terms are not based on colour temperature, but on how we relate to them psychologically. Oranges and yellows (approximately 1700K–3000K) are related to fire and are thus considered warm colours, while blues (above 5000K) are related to water and are called cool colours. So, low-colour temperature hues are warm and high-colour temperature hues are cool.

You've probably seen a related phenomenon in gas flames – the hottest part of the flame is blue, while the orange bottom is cooler. Incandescent lights (classic light bulbs) emit light that has a yellowish character of around 2700K. Halogen bulbs are incandescent bulbs that burn hotter and emit a higher colour temperature light than regular tungsten bulbs, yet their colour is still more yellow than blue, around 3000K. The sun and electronic flash guns emit light that is more strongly bluish. Depending on the time of day, whether it's cloudy or you're in shade, the colour of daylight can vary dramatically.

As explained elsewhere, you should avoid setting your camera to Auto White Balance. You can use any of the following methods to get much better white balance results.

1 Use one of the standard white balance settings (incandescent, fluorescent, flash, cloudy, open shade, sunny).

2. Use a manual colour temperature setting (e.g. 5650 K).

3. Use your camera's White Balance Pre-set option with a neutral grey card to measure the white balance.

4. Shoot a test frame with a grey target and use the White Balance dropper tool in Lightroom, Camera Raw, Aperture, etc. to measure the white balance in the test frame and then apply that setting to other images with the same lighting.

7500 K: Shade

6500 K: Cloudy

5500 K: Daylight, Camera flash

4100 K: Moonlight
3800 K: Fluorescent bulbs

2850 K: Tungsten light bulbs

1850 K: Candle flame, Sunrise/Sunset

▶ **SEE ALSO:** See Select a white balance setting in Chapter 2 for more details on using standard white balance settings.

? DID YOU KNOW?

Sunrise, sunset and candle light are approximately 1850 K. Incandescent lights range between 2700 K and 3300 K. Sunlight can range between 5000 K and 6500 K. Fluorescent lights are a special case. Their light does not come from a heated filament, and they can be manufactured to produce light with colour temperatures anywhere between 2700 K and 6500 K. Warm-white (~2700 K) fluorescent lamps are popular for residential lighting, while cool white (~4100 K) fluorescents are popular for office lighting.

Types of daylight

Not all daylight is the same, and making the most of it comes from being able to recognise the intensity, softness, direction and colour temperature of the light. Some times of the day are better than others for photography, and it may be surprising to you that overcast days and shadowy overhangs can actually be good for portraiture. The colour temperature of daylight varies widely and there are certain times of the day when you may want to emphasise the colour of the light rather than neutralise it.

- Bright midday sun casts harsh shadows and creates high-contrast images. It typically forces you to decide between blown highlights or shadow areas with no detail. Overhead sun can cast shadows that completely obscure the eyes. The bright sun also makes people squint.

- Open shade is found on the shadow side of any building or under an overhang. This can be a great light for making portraits. Put your subject in the shade and turn them so that you can see the ambient light reflecting in their eyes. The light is often very blue, so you'll want to measure the white balance or use the open shade setting.

- Overcast days can be great for photographing flowers or people. The diffuse light reduces shadows.

- The 'golden hours' (or 'magic hours') are the hours just after sunrise and before sunset. The light is coming from a low angle and bouncing off the sky. That produces long shadows, but with lower contrast than at other times of the day. The direct rays of the sun have a very warm colour. If you use white balance or a grey card, that effect will be neutralised. It's best to pick a fixed white balance such as sunny, cloudy, or a colour temperature in the range of 5000–6500 K.

- Pre-dawn and dusk are times when all of the light is diffused and bouncing off the sky. It is a time to be creative with white balance. The light is very blue and contrast is low. Preparation is essential. The light will change minute by minute and you may not have much more than half an hour to shoot.

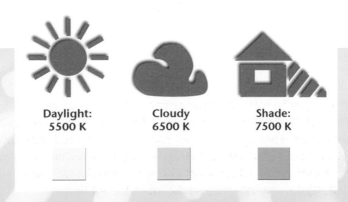

Daylight: 5500 K Cloudy: 6500 K Shade: 7500 K

Types of indoor light

When working indoors, you'll typically encounter lamps with tungsten bulbs, but other available light sources can also be found, including halogen lamps and fluorescent lights in a variety of shapes and colour temperatures. Even television sets can be used as a light source.

- The intensity of indoor light is generally low – that means using some combination of wide aperture, slower shutter speed or higher ISO sensitivity to capture the shots.

- Indoor scenes can often look more like what we experience (slightly dim) if you set your camera to underexpose slightly, perhaps a half stop to as much as a full stop. You can use exposure compensation or Manual mode metering to do this.

- Bare bulbs give off high-contrast light that can look harsh, throw unflattering shadows and blow highlights.

- Lampshades can diffuse light nicely, but they can also add colour to the light. If you want to neutralise the colour, you will probably do better shooting a test frame with a grey card and then using the white balance dropper in your raw processing software.

- Light can also reflect off surfaces and add colour to the scene. Keep this in mind, especially if you ask someone to stand next to a coloured wall. It can also happen with light fixtures that are close to a painted ceiling.

- 'White' fluorescent bulbs have a colour temperature of approximately 3800 K, but they are available in a wide range of colour temperatures. Your camera and software such as Lightroom are designed to neutralise 3800 K, which may not match the actual colour temperature of the lights. A second issue is that fluorescent lamps emit a lot of green light. White balance neutralises the green by adding magenta. Shoot a grey card and neutralise in your raw processing software for best results.

- Other options for shooting indoors include using a tripod or an electronic flash.

SEE ALSO: We'll look at window light as a special case later in this chapter.

**Tungsten
2850 K**

**Fluorescent
6500 K**

Work with bright light

Very bright light, such as midday sun, can be harsh and produce high-contrast images. Often, your camera's default choice of exposure may not be satisfactory. If you have to shoot in such light, the trick is to find ways to take advantage of it and work with the limitations you're given.

One option is to use Active D-Lighting (Nikon) or Highlight Tone Priority (Canon). These features do not work identically, but are designed to protect highlight detail in high-contrast lighting situations. The Nikon system can also prevent the shadows from going completely black. The resulting image may appear slightly dark (underexposed), but this can be adjusted by brightening the midtones in post-production.

Another option is to intentionally over- or underexpose, by using exposure compensation or steering the exposure in Manual mode. In the example here, controlling the exposure prevented the sand and clouds from blowing out, so that they have texture, detail and volume. An added benefit of reducing exposure is that darker colours often become more saturated.

- Shoot raw images. Raw processing will give you the greatest exposure latitude.
- If possible, position your subject so that the sun is to the side or behind them. However, with the light coming from behind, you do have to guard against lens flare.
- For each shot, decide whether the detail in the shadows or the highlights is most important.
- Option A: sacrifice the highlights. When the light is coming from behind, the camera's default settings may produce a silhouette. You can overexpose and let the highlights blow out, which gives the shadows a more normal exposure.
- Option B: sacrifice the shadows. In some cases, the default exposure still results in lost highlight detail. When the highlights are important, you can decrease the exposure and allow the highlights to retain their detail. The shadows will be dark and may go solid black.

- When in doubt, bracket. Bracketing is simply shooting several different exposures of the same scene. If you're bracketing for the shadows, you may make a first exposure at the default settings, then make two more, increasing the exposure by 1-stop.

- If you can, seek open shade, such as the shade side of a building or a covered porch. Trees are often a problem because bright spots of dappled light usually pierce through the leaves and the leaves add a lot of green to the scene, which can create white balance problems.

- Advanced techniques: use HDR for still scenes or fill flash.

 SEE ALSO: Exposure compensation, Manual mode and bracketing are all discussed in Chapter 3.

The direction of light and backlighting

The location of the light source can shape an image as much as the colour and intensity of the light. It determines where shadows will fall and, by extension, how texture and surface details will be revealed. When photographing people outdoors, turning them and standing so that the sun falls at a favourable angle can make a dramatic difference.

- Early in the morning and late in the afternoon, the sun is low in the sky. This produces striking, long shadows and is great light for shooting both landscapes and portraits.

- When lit from the side, the texture of the skin can become extremely obvious. This is something that might be perfect for a 'manly' image, but is less appealing for a beauty shot.

- Backlighting occurs when the sun is behind the subject. The biggest problem is that it can throw your camera's light meter off, resulting in silhouetting. In those situations, you can intentionally overexpose with manual metering or exposure compensation. An alternative approach to backlighting is to use centre-weighted metering. You can place the subject in the centre of the viewfinder, press the shutter button halfway to lock exposure and focus, then recompose before pressing the shutter button the rest of the way. The image on the left is backlit. The exposure was increased to bring out their faces and clothes. Some areas in the background are blown out (pure white) because of this.

- 'Butterfly' light is very flattering for portraits, especially of women. The light source is at a high angle, slightly behind the photographer, producing a small shadow directly beneath the nose.

- The image on the right is essentially Rembrandt. 'Rembrandt' light is a classic light pattern that can be achieved later in the afternoon outdoors, or indoors with a light that you can position. The light travels downwards from between the photographer

and the sitter at about a 45-degree angle across the face, and the sitter tilts their face slightly towards the light. This lights one side of the face and throws the other side partially into shadow. The shadow of the nose joins with the shadow on the jawline to create a bright triangle of light under the eye on the dark side of the face. Every face has a different shape, so the precise angle of the light necessary to produce the effect will vary.

 HOT TIP: An advanced technique for dealing with high-contrast backlighting is to use fill flash. The flash is set so that it doesn't dominate the scene but throws enough light to keep the subject from becoming a silhouette and to prevent the background from being too bright.

Lens flare and halation

Lens flare and halation (a softening of the image that can look like fog) are caused by unwanted light entering the lens. Light that forms the image enters the lens after bouncing off the scene, but the light that causes flare and halation travels straight into the lens from the light source. Lens flare often happens when the light is just barely behind the subject. Halation can be caused by light entering the lens at a more oblique angle and can noticeably reduce contrast. Fast lenses are more prone to halation, and wide apertures (e.g. $f/2$) are more prone than smaller apertures.

- Use a lens shade whenever light is coming from a more oblique angle.
- Try using your subject to block direct light if you encounter lens flare.
- You can use a hand or any object to 'flag' the lens and keep light from entering. Just be careful to keep your flag out of the shot.
- Of course, there are times when you'll want to allow or intentionally cause lens flare for creative purposes.

Soft light and window light

Windows can be a source of beautiful soft light because they can function as a big reflected light source: the larger the window, the softer the light. Reflected light is always softer than direct light. Nearby buildings or even the sky can serve as reflectors. Soft light is very flattering for portraits because it produces subtle shadows that can reveal the sculpture of a face or figure without a lot of texture. Sheer or translucent curtains offer a second level of diffusion that can further soften the light. They also soften the light in the case where you can see the sun through the window. Often, you can stand someone near a light-coloured wall that is reflecting bright, direct sunlight for a soft light effect.

- Stand between the window and your subject for beautiful, even portrait light.

- Face your sitter with the window at their side for more dynamic lighting.

- Move away from the window for other variations. The light will decrease in intensity but will become softer near the edges of the pool of light from the window.

- Daylight is very blue compared with tungsten light bulbs. The daylight or open shade white balance settings are likely to produce good results.

- Keep in mind that the colour of reflected light is influenced by the colour of the surfaces it bounces off. That may affect white balance or even require other colour-correction strategies.

- In the example photo, two windows are mediating the light falling onto the subject (one to our right and one behind and to the left). The result is soft highlights and gradual shadows. Placing her close to the window on the right produced that specific look.

 HOT TIP: North-facing windows are a great, soft light source coveted by many painters and sculptors, along with photographers. They never get direct sunlight and the illumination is consistent through the daylight hours. Like open shade, the light is very blue.

Work with dim light

Moonlight, candles, a torch, a TV screen, a mobile phone and street lamps are all examples of dim light sources that can be the basis for a dramatic image. You can control the exposure to create a low-key image with a few moderately bright areas and lots of mysterious darkness. You'll need to adjust any or all of the settings for shutter speed, aperture and ISO to get a good exposure. We tend to see light as being warmer in low-light situations. You can often let your colour-temperature correction stray towards the yellow end of the range. Such images often look even more powerful in black and white.

- The default choice of shutter speed and aperture produced by auto-exposure can be too bright. You can use exposure compensation or Manual mode metering to intentionally underexpose the image.
- Low light generally requires slow shutter speeds. Intentionally moving the camera during long exposures can create fascinating light trails, but otherwise you'll probably want to use a tripod or monopod to stabilise the camera.
- Opening the aperture to allow more light into the camera can allow for faster shutter speeds but also produces shallower depth of field.
- Increasing the ISO can allow you to use much faster shutter speeds but may produce unsatisfactory digital noise. Full-frame cameras such as the Canon 5D and the Nikon D700 perform much better in high-ISO settings.
- It's best to shoot in raw (and in colour). This gives you the greatest flexibility in post-processing. You can convert to black and white by a number of methods in post-processing.

SEE ALSO: Exposure settings and their effects are explored in depth in Chapter 3.

5 Selecting and using lenses

Introduction

Your choice of 'glass' can dramatically shape the appearance of the images that your camera produces. Some of the factors that the lens affects are sharpness, colour, spatial perspective, depth of field and the quality known as bokeh. Beyond the optical performance of the lens, its weight, focusing mechanism and other factors can affect your camera's operation.

Focal length and the crop effect

The focal length is a measure of how a lens bends light rays. Along with the 'speed' or maximum aperture of the lens, it is one of the main characteristics that distinguishes how a lens performs.

Lenses are typically categorised as wide-angle, normal or telephoto according to their focal length. As the focal length increases, distant objects are magnified more. As the focal length decreases, the angle of view increases and the lens bends light rays more sharply. Thus, wide-angle lenses have the shortest focal length and telephotos have the longest.

Because most digital SLR cameras are based on the 35 mm film format, we typically look at the focal length of lenses in terms of the 35 mm film standard. On a 35 mm camera, 50 mm lenses are considered normal, while lenses with a focal length of 35 mm or less are considered wide-angle and lenses with a focal length of 85 mm or more are considered telephoto.

Most digital cameras have what is referred to as a cropped sensor – one that is smaller than a frame of 35 mm film. This effectively increases the focal length of any lens you attach to the camera. In other words, on a camera with a cropped sensor, a lens with a focal length of 50 mm produces an image that looks as though it came from a longer lens. Cameras with cropped sensors have a 'focal length multiplier' or 'crop factor' that you can use to determine the effective focal length of any lens. Full-frame cameras such as the Canon 5D and the Nikon D700 have sensors the same size as a frame of 35 mm film, and thus do not have a multiplier (actually, their multiplier is 1).

To determine the effective focal length of a lens, multiply its actual focal length by your camera's focal length multiplier.

- For all Nikon DX cameras (their designation for the cropped format), the multiplier is 1.5, which makes a 35 mm lens effectively 50 mm.

- For most Canons with cropped sensors, it's 1.6. So, a 28 mm lens acts like a 45 mm and a 35 mm is effectively 56 mm.
- The multiplier's effect is to convert what was a wide-angle lens into a normal lens and what was a normal lens into a mild telephoto lens.

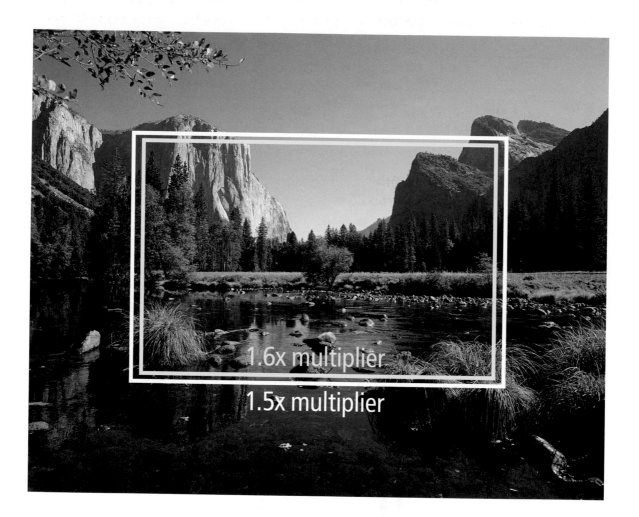

1.6x multiplier

1.5x multiplier

WHAT DOES THIS MEAN?

Digital lens: every lens actually projects a circular image into the back of the camera, and that circle needs to be large enough only to cover the entire sensor. Digital lenses are designed to project a smaller circle than a traditional 35 mm lens, but sufficient to cover the smaller sensors. As a result, they can be made smaller and less expensive. The implication is that they can't fill the entire sensor of a full-frame camera. Nikon's full-frame cameras automatically switch to a cropped mode when you attach one of their DX lenses.

Depth of field and pre-focusing

Focusing can take a substantial amount of time – enough time to make you miss your shot, even when you use auto-focus. An alternative is to pre-focus your lens and turn off the auto-focus mechanism before you begin shooting. Once you pre-focus, everything that falls within the focus range of the camera will be sharp whenever you trip the shutter. It's a very useful technique for whenever you can anticipate where the action is going to happen.

One way to pre-focus is to use auto-focus to lock in on something acting as a stand-in for the subject and then turn off the auto-focus. The other approach is to turn off the auto-focus first and use the markings on the lens barrel to dial in a focus zone as shown below.

1 Note the pairs of marks on the barrel corresponding to each of several aperture settings (e.g. $f/11$, $f/16$ and $f/22$).

2 Turn the focus knob until the range of distances that you want to have in focus falls between a pair of aperture marks (e.g. $f/16$).

3 With your metering system set to Aperture Priority, set your aperture to the indicated value and the camera will select a shutter speed for you.

Or

4 Instead of steps 2 and 3, use the hyperfocal setting. Select an aperture such as $f/11$ and align the infinity sign on the focus ring with the corresponding mark on the barrel. This produces a very deep field of focus.

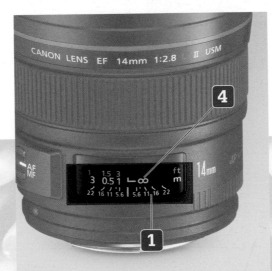

'Normal' lenses

A 50 mm prime lens is the classic 'normal' lens in 35 mm film photography. Its perspective most resembles that of normal human vision and some of the greatest names in photography, such as Henri Cartier-Bresson, have shot with it exclusively. In the golden age of film, it was the lens that came with most cameras. Lenses in the range of 28–35 mm are the equivalent on cropped-sensor cameras such as the Canon Digital Rebel and Nikon D7000, depending on the camera's crop factor. The normal lens has a broad range of applications, from portraits to landscapes. Some of the benefits of the normal lens are the following:

- Sharp: These lenses can be extremely sharp, giving fine detail that can't be matched by zoom lenses.
- Lightweight: The low weight and compact form of the lens make it easy to use for hand-held shots and easy to carry.
- Fast and inexpensive: You can get a 50 mm f/1.4 lens for a very reasonable price. The aperture of 1.4 allows fast shutter speeds in low light and a shallow depth of field for portraiture and still-life shooting.

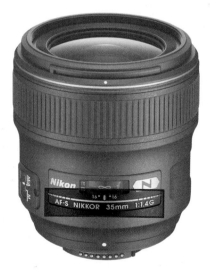

35mm → 50mm
on 1.5x Nikon multiplier

'Fast' lenses

Lenses with a wide maximum aperture, say in the range from $f/1.4$ to $f/2$, are known as fast lenses. All of the fastest lenses are prime lenses, meaning they do not zoom. They offer the opportunity to use faster shutter speeds and create shallow focus effects that zoom lenses, such as the 18–55 mm $f3.5$–5.6 lenses that come with many cameras from Nikon and Canon, cannot match.

Aside from aperture, another distinguishing feature among fast lenses is the quality of the bokeh, which is the way out-of-focus areas of the image are rendered. Lenses with good bokeh are particularly good for making portraits where the subject's face is in sharp focus, while the background is reduced to a soft, painterly blur that can add beautiful atmosphere.

 HOT TIP: Depth of field becomes shallower as you increase the size of the aperture. Expect to pay a premium for one or two extra stops. $f/1.4$ lenses are more than double the cost of $f/1.8$ lenses.

Telephoto lenses

Lenses with focal lengths (or effective focal lengths) greater than 50 mm are considered telephoto lenses. They allow you to magnify distant objects and are sometimes referred to as long lenses. 85–135 mm lenses are considered medium telephotos, while lenses with focal lengths of 300 mm or more are considered super telephotos.

The two lenses illustrated here are a 300 mm super-telephoto from Canon and a 70–210 mm zoom telephoto from Nikon. Both are fast f/2.8 lenses. On cropped-sensor cameras, the Nikon lens is effectively 105–315 mm with its 1.5× multiplier, while the Canon lens becomes a 480 mm lens with its 1.6× multiplier.

Telephoto lenses have applications in sports and wildlife photography, but can also be used creatively because of their tendency to make distant objects appear nearly the same size as objects that are close. This effect is known as compression or telephotodistortion, and you can see its effect in the traffic image here.

- Long prime lenses can be heavy in their own right, and telephoto zoom lenses can be even heavier, making them susceptible to camera shake.

- It is not unusual to use a monopod or tripod mount with such lenses, and many long lenses come with a mount on the barrel, like the one shown on the Nikon.

- A number of telephoto lenses offer an anti-shake feature called VR (Nikon's term, short for vibration reduction) or IS (Canon's term, short for image stabilisation), which reduces the effect of camera movement.

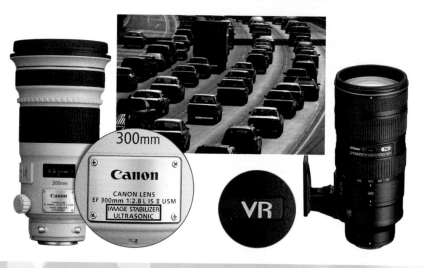

 HOT TIP: With the typical crop factor, a 70–210 zoom operates as if it were approximately 110–330 mm. That converts the long end of the range from a medium telephoto to a super telephoto.

Wide-angle lenses

Wide-angle lenses have focal lengths shorter than 50 mm. They allow you to take in more of the surrounding environment when working close to a subject and they have a greater depth of field than normal or telephoto lenses. The optical effect of wide-angle lenses is to exaggerate the difference in size between objects that are close and those that are distant, the inverse of what happens with long lenses.

- As the focal length gets shorter, wide-angle lenses are increasingly prone to barrel distortion – straight lines can appear to have a strong curvature.
- Many of these effects become even more pronounced as you tilt your camera along any axis relative to the subject.
- Because they tend to exaggerate the size of the nose and distort the face, wide-angle lenses are not well suited for portraiture.
- The same tendency towards distortion makes wide-angle lenses useful for imparting a surrealistic mood to images.

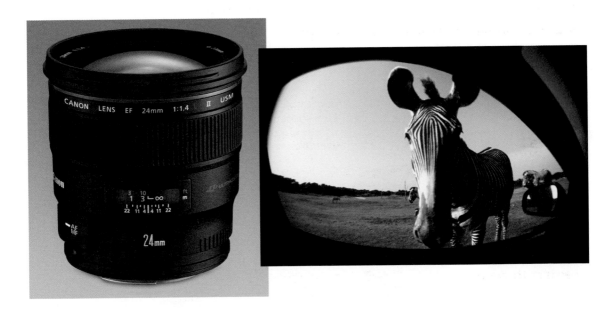

? DID YOU KNOW?

The signature style of famous street photographer Garry Winogrand relied heavily on his use of a 35 mm lens and pre-focusing.

Prime versus zoom lenses

Prime lenses are those with a fixed focal length. Their design is simpler than that of zooms, which means you can often get a better-performing lens at a lower cost. The main advantage of zoom lenses is convenience. They're great for situations where your movement is restricted, and one or two zooms can often cover all the focal lengths you use regularly. With prime lenses, the only way to change the framing of your shot is to use 'sneaker zoom', moving closer or backing away as needed. With a zoom, you can simply turn a dial.

The downside of zoom lenses is their complexity and weight. The weight means you'll have more camera shake at slow shutter speeds, and the complexity often means the zoom won't be as sharp as a prime lens, especially at the low end of the range. Some of the fastest zooms are in the range of $f/2.8$, but many cameras come with kit lenses that range between $f/3.5$ and $f/5.6$ (roughly 1–2 stops slower). With apertures like that, you can't throw the background out of focus the way you can with something like a 50mm or 85mm $f/1.8$.

You can often find a $f/2.8$ prime lens for a fraction of the cost of a zoom. Many $f/1.4$ prime lenses are available, but you pay a premium for the really fast lenses, which can cost as much as the better zooms. Still, you can't beat them for sharpness or the bokeh they produce when you shoot at $f/1.4$ or $f1.8$.

24–70mm $f/2.8$

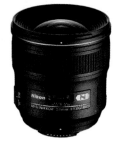

Visual size comparison is only approximate. The zoom weighs 4x as much as the prime.

24mm $f/1.4$: 2 stops faster

 SEE ALSO: Chapter 9 looks at how to remove noise.

 HOT TIP: Using shutter speed to compensate for the aperture, a 2-stop difference equates to going from 1/125s with the fast lens to 1/30s with the slower lens.

 DID YOU KNOW?
Using ISO to compensate for the aperture, a 2-stop difference could mean going from ISO 200 to ISO 800. On cropped sensor cameras, this is the point where digital noise can begin to become a significant problem.

Variable aperture zooms

Lens manufacturers can employ a variable aperture design to keep down cost, size and weight. These can be good general-purpose lenses that are far more affordable than their high-performance siblings.

The aperture setting of variable aperture lenses decreases continuously from its maximum over the range of the zoom. For example, an 18–200mm f/3.5–5.6 lens loses 1–⅓ stops as you zoom from 18–200mm.

The lens shown here is a Nikon DX lens, meaning it was designed for a cropped-sensor camera. If you attach a DX lens to a full-frame Nikon camera, the camera will automatically shoot 1.5× cropped images. The lens also has VR, which reduces the effect of camera shake at slower shutter speeds.

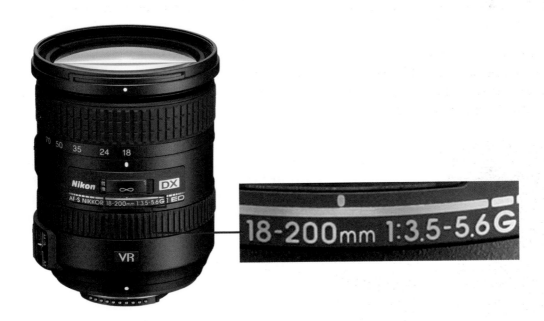

 HOT TIP: A practical implication of variable aperture zooms is that you'll see your shutter speed drop correspondingly to compensate for the decrease in light as you zoom to increase the focal length.

Lensbaby – selective focus with a tilt

The Lensbaby Composer and Composer Pro are special-effects lens systems that allow you to creatively apply selective focus to your image. Viewers pay more attention to the areas of sharp focus within an image and less attention to areas that are not sharp, making focus a powerful composition tool that you can use to create emphasis. An interchangeable optics system allows you to choose the look of the bokeh produced by the lens. In fact, these lenses introduce aesthetically pleasing forms of distortion that you can use to shape the mood and atmosphere of your images.

Shallow depth of field is one example of selective focus, where you throw the foreground, background or both out of focus to emphasise the subject. Lensbabies take the idea a step further, allowing you to place a pool of sharpness (the 'sweet spot') anywhere within the frame, while the rest of the image goes soft. So, instead of simply rendering the background out of focus, you can make a portrait that emphasises the face and de-emphasises the hands.

All but one of the Lensbaby models work by mounting the lens on a turret, which allows you to swing its axis relative to the camera's sensor and moves the sweet spot. As with depth of field, the intensity of the out-of-focus effect decreases with smaller apertures (as you increase the f-number).

Most of the optics in the Lensbaby system have a 50 mm focal length and use interchangeable discs to control the aperture. The Sweet 35 optic has a 35 mm focal length and an adjustable bladed aperture. The 35 mm focal length is equivalent to 50 or 56 mm, and 50 mm is equivalent to 75 or 80 mm with a 1.5× or 1.6× crop factor. Macro, telephoto and other modifiers are available for use with Lensbaby optics, making the system a very flexible tool.

> **? DID YOU KNOW?**
>
> The Composer models are only two of many models from Lensbaby. You can see an impressive array of sample images and explore the constantly expanding range of models, optics and accessories at lensbaby.com.

 HOT TIP: The example here is by Heather Jacks and was shot with the Lensbaby Single Glass Optic.

 ALERT: Lensbabies are manual-focus, non-CPU lenses. You'll need to meter in Manual mode or use a hand-held meter, and auto-focus won't work. It also means that the camera won't record any lens metadata. If you want to keep track of lens information, take notes as you shoot, and add them to your metadata via Lightroom, Bridge, etc.

Macro lenses

Macro lenses can focus much closer to the subject than normal lenses, allowing you to photograph things at actual size or larger. Some manufacturers, such as Nikon, refer to their macro-focusing lenses as 'micro' lenses.

- Dedicated macro lenses offer the best performance for macro work.
- Some lenses have a macro mode switch that converts them for macro work.
- Different types of attachments are available to adapt normal lenses for macro photography, but they all have optical or operational side effects that may be unsatisfactory.

 HOT TIP: Close focusing can result in extremely shallow depth of field. You can increase the depth of field by using a higher aperture number, but this typically requires slower shutter speeds, a tripod, brighter light, or all three. A number of macro-focusing lenses also feature VR or IS stabilisation.

Change lenses

Unless you only use a single all-purpose lens on your camera, you'll sometimes need to change lenses. It's a pretty straightforward process, but there are a couple of things to keep in mind. Every time you open the camera, there's a chance that dust particles can get inside and eventually settle on your camera's sensor.

- Avoid changing lenses in dusty or sandy places. Particles inside the camera can do more damage than creating spots on the sensor.
- Turn off your camera before you change lenses. When the camera is on, the sensor is charged and tends to attract dust.
- Press and hold the lens release button, and then turn the lens to remove it. If you're used to the way that screws unscrew and jars open, it's hard to remember that some lenses (e.g. Nikon) come off by turning in the opposite direction.
- Replace the cap on the rear of the lens and put the new lens onto the camera as soon as possible.
- To attach a new lens, align the dot on the lens barrel with the dot on the camera, seat the lens and then turn to lock.

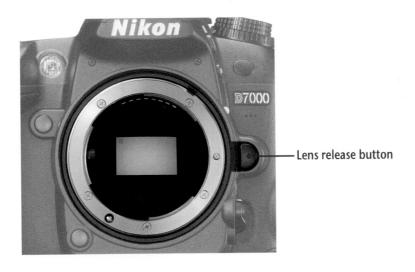

Lens release button

6 Composing better portraits

Introduction

Portraiture is storytelling and there are many approaches to it. For example, it can be candid or formal, intimate or environmental. A portrait can be about what someone looks like, what they do or even hint at their personality.

Every portrait starts with a few key choices. How you frame the shot – what you include or exclude – makes a substantial difference. Then there's the question of what you want to say and how you say that in a photo.

In this chapter, we'll look a bit more closely at some elements and creative choices that can make your portraits stronger.

Framing

The frame is the stage where the story of your portrait will be played out. When you set out to make a portrait, it's useful to consider where to place the subject within the frame, what to include with the subject (or what part of them) and the relationships between people or things within the frame. How close you stand to the subject and what lens you choose will make a big difference.

We'll distinguish framing in-camera from cropping after the fact, although a lot of people refer to the boundaries of any photograph as 'the crop'. The examples here only hint at the possibilities of framing.

The extreme close-up on the left makes the kid's hair the main character in the story, with his big smile in a supporting role. The portrait on the right is perfectly solid, but the overlays show several alternative approaches that would also make great portraits.

- Moving in fills the frame with the person and creates a sense of intimacy.
- Pulling back can show increasingly more of the body, what the person is wearing and even what the environment looks like.
- It's difficult to create a sense of intimacy in a shot that is shot from a distance.
- Wide-angle lenses can show more of the environment when you are working close, but can potentially distort the face or body in ways that are unflattering.

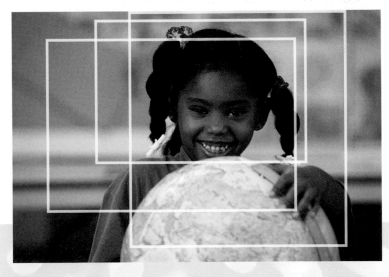

Orientation: portrait or landscape

Vertical orientation, as shown in the right-hand image here, is called portrait because it gives room for the person and not much else inside the frame, unless you pull way back. It's also the orientation that most magazines use for a single page.

The landscape (horizontal) orientation, shown on the left, is more environmental. You generally have to pull back to get the whole person into the shot, which includes a lot of the environment, but a lot more environment around them will still show when you're in close.

Simplify

Great portraits are often a case of less is more. You want the viewer to focus on the person and what you want to emphasise about them. Quiet backgrounds are generally better than busy ones, and the more you can reduce the scene to just the salient elements, the more effective it will be. That doesn't mean eliminating the environment if it's an important part of the story, but the setting can compete with the subject. The irony is that it can take thoughtful effort to make an image appear simple.

In the example here, key elements are the careful framing that completely eliminates the woman's hands, the flower and her direct but approachable gaze. While this portrait clearly uses studio lighting, you can get similar results with the diffuse light from a window. The shadow of the flower and her nose indicate where the light source was. Any light above and to the side can be good for making portraits.

Get closer

Whenever you move closer to the person you are photographing, it increases the sense of intimacy. Whatever chemistry you have with the subject may also be revealed in their facial expression or body language.

- Whether the subject is gazing into the lens, looking through you, or looking at something else will have a strong effect on the mood and how people seeing the photo will relate to it.
- Lenses with an effective focal length in the range of 85–150 mm can give you tight framing without being right on top of the person or having to stand too far away.
- Wide-angle lenses often force you to move in much closer to get the framing you want, and they often distort the face in unappealing ways.
- Macro-focusing lenses allow you to get so close that the subject can be reduced to an eye, a pair of lips, a nostril or a mole on the cheek. In a sense, the person becomes anonymous.

Watch the fingers!

Tight framing means things fall out of the frame, and that can be a good thing. For example, when the edge of the frame cuts through the forehead, as illustrated in the left-hand image, it can emphasise the eyes and create an even more intimate connection with the subject. But, if the frame cuts awkwardly through the hands, wrists, toes, feet or ankles, as in the right-hand image, it can read subconsciously like an uncomfortable amputation. Clipping off the feet is even more problematic in shots where there is plenty of space above the subject.

 HOT TIP: If you have time, you can run your eye around the edge of the viewfinder just prior to tripping the shutter. A gentle alteration of position or tilt of the camera can bring fingertips or toes right to the edge but inside the frame before you burn a frame.

Keep an eye on the background

When you're not framing so tightly that you're at risk of clipping body parts, there is the chance that something unwanted will creep into the background. Our eyes tend to focus on the centre of the frame and not notice the edges, so once again it's a good idea to run your eyes around the edge of the frame just before you squeeze the shutter.

Another background-related problem that can occur is unwittingly grafting things from the background onto the subject of your portrait. Taking a half stride to the right or left or moving your subject a little can resolve a lot of issues that can weaken a photo.

In the example shown here, the child in the foreground is the main subject, but another child is reaching up and interacting with one of the adults in the background. The child in the background seems to be growing out of the subject's head, and the frame slices through his or her head. Shifting the child in the foreground slightly to the left (or stepping to the right) would have avoided the overlap. Either tilting the camera upward, zooming out, or taking a stride backward would have included the people in the background without slicing through them so drastically.

Make your portraits environmental

Environmental portraits are great for conveying things about people's lifestyles, workplaces, activities, even their personalities. A close-up can show the excitement of a smiling child, but pulling back so that the child is framed by a swing set tells the story of a great day at the playground. Intimate portraits can reveal the twinkle in someone's eyes or the subtle dimple in their cheek, but environmental portraits can tell us more about the world that someone lives in.

In the example shown here the clutter of the room gives meaning to the boy's facial expression and gesture. Keeping the focus relatively shallow emphasises the subject, so that the room and its contents are secondary elements of the story.

When working in close quarters, a wide-angle lens may be best suited for capturing more of the environment. The spatial distortion that can come with such lenses is less of a potential problem in the context of an environmental portrait.

 DID YOU KNOW?

The 35 mm lens was a mainstay of many documentary photographers who often shot environmental portraits on film. Full-frame cameras have the same optical perspective, but you'll need something in the realm of 24 mm to approximate that with a cropped-sensor camera.

Isolate with depth of field

Focus is a powerful way of directing the viewer's gaze. When you reduce the depth of field so that only the subject's face is in focus, you literally *make* the viewer focus on the subject. You need a fast lens (e.g. *f*/1.8 or faster) to get the shallowest possible focus. You'll have trouble getting shallow focus with many zooms.

? DID YOU KNOW?

Many people refer to depth of field as DOF. When using shallow focus for portraiture, you'll usually want to lock your focus on the subject's eyes.

Keep the horizon horizontal

When the horizon tilts, it can have a destabilising effect on the whole image. It's best to try to keep the horizon line as horizontal as possible. Most cameras can help by showing guidelines in the viewfinder. You may have to consult your manual to find out how to turn them on.

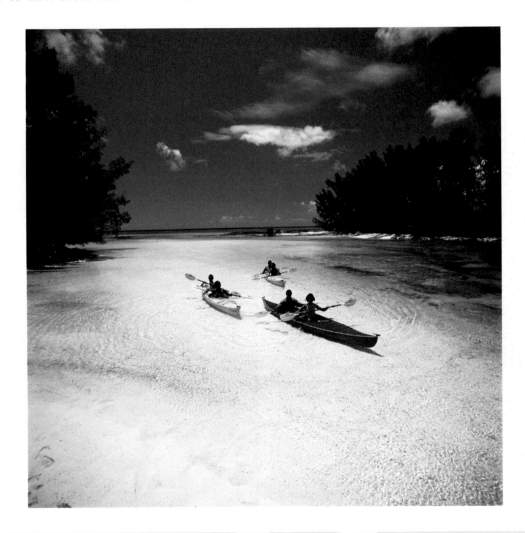

Change up your angles: use extreme perspective

Two examples of extreme perspective are worm's eye view (see picture on left) and bird's eye view (picture on right). You can inject energy and drama into your image by intentionally shifting the camera so that the horizon is tilted in the extreme. Because of the way that wide-angle lenses bend light, an ordinary scene can become extraordinary simply by shooting from the hip with a tilt.

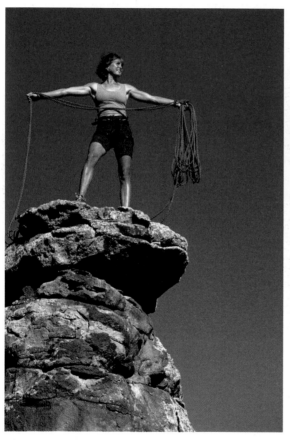

 HOT TIP: If your horizon isn't horizontal, it should really tilt; a slight tilt looks like an accident.

Give your subjects leading space

Framing for tension can go awry when it looks as if the subject is moving in a particular direction. You generally want to leave leading space so that it doesn't look as though they're walking into a wall at the edge of the frame.

When your subject is in profile, and especially when they seem to be looking in the direction that they are facing, it often looks as though they are heading in that direction. If the person looks as though they are heading to the right they will run out of leading space if you place them at the right edge of the frame. Placing them on the left side of the frame with plenty of leading space will maximise visual tension and usually looks much stronger.

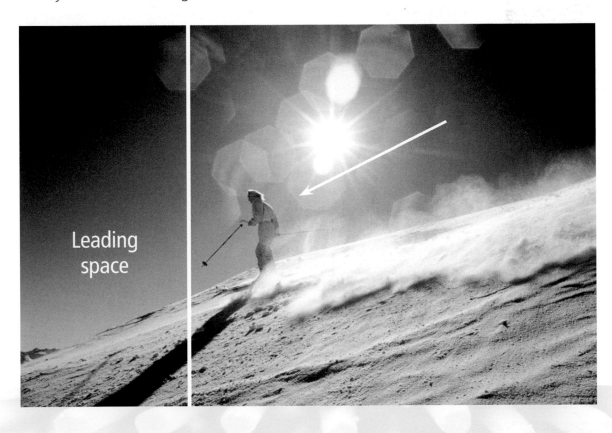

Leading space

7 Composing better images

Introduction

In this chapter, we'll explore principles of composition as a way of philosophising about what makes a picture work, drawing from graphic design as well as photography. Ideas about composition should be taken as guidelines or principles, not rules, and certainly not laws.

Framing (as opposed to cropping in post-production) is an important compositional choice that's based on exclusion – pointing the camera imposes its frame upon the scene and subtracts everything that falls outside of the frame. In some cases you can direct the action and move people or objects into the frame to construct the scene. But more often than not, you'll need to move to get what you want inside the frame. You might stand on tip-toes, squat, climb a ladder or roll onto your stomach just to find a compelling view. When you look through your viewfinder, it's helpful to look not only at the subject but also at where the subject is positioned within the frame and what surrounds her, him or it.

For any given image, the shape of its frame (its aspect ratio) can affect the way the image is perceived. In particular, the corners of the frame and its dimensions create expectations in the viewer about where to look for important elements within the frame. This goes back to the camera and the way your lens bends light, because the lens actually projects a circular image into the camera. But what the viewfinder presents, and what the camera records, is a rectangular image. As we've seen elsewhere, full-frame cameras carve out a larger area of that image than cropped-sensor cameras do. Digital SLR cameras take their lead from 35mm cameras and carve out an area with a 2:3 aspect ratio. There's nothing that says digital cameras couldn't be built to record 6:7 or even 1:1 images, both of which are common formats for cameras that shoot film. You can select those formats and more when you crop.

The principle of thirds

Composing on the basis of dividing an image into three equal segments from top to bottom and again from left to right demonstrates an application of what is often termed the 'rule' of thirds. However, it's not really a rule, since it's not the only way to compose an image.

- One successful way of working with this principle is to use the image segments, whether vertical or horizontal, as containers. For example, if your sitter is in an outdoor setting, you might frame the image so that the sky occupies the top two-thirds of the frame and the ground occupies the bottom third. Looking horizontally, the sitter could be positioned so that most of the body occupies the middle third.

- The points where the horizontal and vertical dividing lines meet have additional weight. You could call them pressure points. Placing an element of your composition on one of these points will focus attention upon it. One way to call attention to your subject's face is to place the eye on the pressure point at one of the intersecting thirds.

Use negative space and tension

The empty space around the subject is known as negative space, and shaping that space can make your compositions stronger. Visual tension (top) and trapped space (bottom) are two examples of working with negative space. Some ways of composing with negative space are listed below.

1 The absolute centre of a picture is often referred to as 'dead centre'. From a perceptual standpoint, placing something in the centre deadens it. As we move the point of interest away from the centre, visual tension increases.

2 When the subject places a hand on their hip and pushes their elbow away from their body, it can create a diamond-shaped space between the arm and the torso. This is an example of trapped space. Another example occurs when you make a tightly framed portrait.

3 The sitter's face, shoulders and torso can divide the frame so that the background is cut into a shape that is trapped between the sitter and the edges of the frame.

Use symmetry

A composition can benefit from symmetry or be completely boring because of it. Reflections can create symmetry where there was none and building designs can be strongly symmetrical. In either case, the way you frame the symmetry will make a difference. You can align the axis of the symmetry horizontally, vertically, both, or even diagonally.

In the illustration on the left, the tree branches reflected in water challenge you to read the axis of symmetry clearly. The resulting patterns resemble snowflakes. The Taj Mahal image shows architectural symmetry aligned with the vertical axis of the photo, while the reflecting pool creates a second symmetry along the horizontal axis. Elevating the axis of the horizontal reflection above the centre line of the image adds visual tension. The composition is also organised around the principle of thirds.

? DID YOU KNOW?
Vertical symmetry is a way of creating visual balance. The elements on either side of the visual centre have the same weight, and balance each other.

? DID YOU KNOW?
You can also have asymmetrical balance, where items with different visual weights balance each other. For example, a small object far from the centre can balance a larger object that is close to the centre. It works like a lever, where the visual centre of the image is the fulcrum.

Crop for composition

The shape of the frame, also known as aspect ratio, comes into play when you crop an image in post-production, and it can have a subtle yet powerful effect on how people look at your photos. The key is to use proportions that are meaningful or practical. Graphic designers know that certain rectangular shapes look more 'correct' to people, and in each case the lengths of the sides relate to each other in a particular way.

Cropping is really recomposing the image after the fact. You get to change the shape of the frame if you like, but you also get to decide where certain elements sit within the frame. When you crop in Lightroom, the crop tool shows overlays that can help you gauge the position of those elements.

- Digital SLR photos are based on the 35mm format aspect ratio of 2:3. When you crop to remove something from a shot by dragging one side in, it changes that aspect ratio. You rarely get a composition that has its own integrity and that weakens the image.

- Proportions such as 6:7 and 1:1 are common aspect ratios for cameras that shoot film. Their more squared-off shape changes the relationship between the subject and the background. These are just some of the formats you can select when you crop.

- You can give your images a more cinematic feel, simply by cropping in one of the proportions used in film and video, such as 16:9 or 2.2:1.

- The default overlay is a grid divided in thirds, but you can tap the letter O key to see other compositional aids. Photoshop has a more limited set of overlays within its crop tool.

SEE ALSO: The cropping tool in Lightroom allows you to select popular aspect ratios or dial in your own. It also offers several cropping overlays that help you compose more effectively. See Chapter 9 for more details.

Frame in frame

Composing around an inner frame can be a powerful technique because it doubly focuses attention on the subject. Windows and doorways in a shot can all have the effect of creating a frame within the frame. Mirrors can create a frame within the frame while imparting symmetry or a dual perspective as well.

- A framing element does not have to be a literal frame. It can have as few as two sides and consist of a striking colour, texture or shape.
- For fashion, portraits and glamour photos, models often create a framing effect by surrounding their faces with their arms.
- Portrait photographers often project a circular or oval pool of light onto the background behind the sitter to create a framing element.
- A mirror can be especially interesting when used as a frame because it can show two perspectives on the same scene, perspectives that can even seem to disagree.

Points of interest and shapes

You can strengthen an image by basing its composition around shapes. Triangles, diamonds, circles and squares are all primitive, flat shapes that our eyes are particularly attuned to find. Shadows and silhouettes transform complex volumes into flat shapes, often revealing a surprising projected shape in the process.

The shapes in an image do not have to be literal. Instead, elements of visual interest inside the frame can suggest the shape, in the same way that stars in a constellation do. Many Renaissance paintings were composed of figures arranged in triangles.

Use lines

Just as our eyes are tuned to detect shapes, they are tuned to detect lines. In fact, it's likely that our tendency to see lines is part of what allows us to see shapes in the first place. Lines can be painted or drawn, they can be edges, or they can be seen in repeating shapes or patterns.

Any line will lead the eye through the frame. When used strategically in a composition, we refer to them as leading lines. Such lines often direct the viewer's attention to the sitter, but they can also help to describe the space around the sitter. Lines that we perceive to be parallel yet converge in the image demonstrate a vanishing point.

- Our eyes are particularly attuned to finding lines, especially verticals, horizontals and diagonals. The key thing to watch out for is that you don't capture or emphasise lines that lead the eye completely away from the subject.
- Sloping, curved, bent and spiral lines are particularly good for adding a sense of energy and motion to an image.
- Your compositions can also be made up of implied lines, such as the line that connects the pupils and the vertical from the forehead to the chin.
- Patterns, textures, lines and shapes are all closely related.

Patterns, textures and repetition

Lighting can bring out texture. Flat, soft lighting reduces the sense of texture, while higher-contrast, edge-wise lighting emphasises it. Texture can be a powerful, and often sensual, compositional element.

Patterns are about repetition and work a bit like texture. Lighting effects such as the stripy shadows cast by louvre slats and the dappled light of a tree canopy are examples of patterns. When you use a wide aperture to create shallow depth of field, backgrounds can be reduced to patterns of repeating soft shapes.

The spatial compression characteristic of longer telephoto lenses can also be used to emphasise patterns in architecture. Distant buildings are magnified and appear to have the same scale as buildings nearby.

Compose with colour

The compositional techniques described so far do not need colour to be effective; in fact, colour can complicate matters. However, with a little understanding, you can take advantage of the compositional power of colour to create images that work because they use colour, not in spite of it.

Colour helps us to identify things; for example, we recognise ripe fruit by its colour. It can also convey mood and emotion (e.g. the terms 'feeling blue' and 'purple passion' are two strong emotional states that are closely tied to colour. Colouring something blue can suggest a blue mood, and colours like purple and red are closely associated with passion). Two things to become familiar with are the main qualities that define colours and the two different colour wheels.

We have two different colour wheels in part because the RYB wheel that artists use is derived from perceptual activities and mixing pigments, while the RGB wheel comes from the physics of mixing light. The two wheels arrive at different pairings of complements, and both are useful for composing with colour. It's best to memorise the pairings of complements for the two wheels. In the RGB model, the complementary pairs are red/cyan, green/magenta and blue/yellow. In the artistic RYB model, the pairs are red/green, yellow/violet and blue/orange. The idea of complements is that they cancel each other out. Mixing pigments with their complement creates a muddy brown, while mixing complementary colours of light produces either neutral grey or white.

Hue, saturation and value (generally referred to as brightness, lightness or luminance in programs like Photoshop) are the three main qualities that distinguish colours. Each colour that we know by name is a hue, while saturation is the purity of the colour. Adding white to pure red reduces its saturation and creates a tint – pink. Adding black to a hue creates a shade. Shades and tints are collectively known as tones. Some tactics for composing with colour are listed below.

- You can look for colour relationships in the scene and frame the shot to emphasise the colour relationships. The example photo uses the analogous (adjacent) colour

harmony of blue, green and yellow in the artistic colour wheel. If the green were less pronounced, yellow and blue are complements in the RGB model.

- In processing, you can reduce the saturation of an image to make subtle use of a pastel-like colour palette.
- Cyanotype and sepia-toned prints are done by blending solid colour over a black-and-white version of an image.
- Duotone images are typically created by tinting the shadows with one hue and the highlights with a complementary hue. You can also contrast warm and cool hues, instead of strict opposites.

Compose with motion and time

Fast shutter speeds allow you to freeze action at its peak, which can make for dramatic images, especially when the subject is sport. At the other extreme are 'drag shutter' effects, where you can use motion to create ethereal imagery.

A photograph compresses four dimensions into two. In addition to translating the three dimensions of height, width and depth into a flat image plane, a photograph represents the passage of time. If the exposure is long enough and the subject or the camera moves, you'll get a motion trail or a ghost. Long-exposure shots of moving water can produce surprising results.

- When the camera is mounted stably (e.g. on a tripod), the contrast between stationary and moving elements can be striking.
- Panning with a subject such as a runner or cyclist as they pass you will make the subject look relatively stationary while the background blurs.
- Walking while shooting creates contrasting motion effects – the up-and-down bounce of the camera versus the motion of elements within the scene.
- Slow-sync and rear-curtain flash settings combine the motion trail produced by the ambient light with a frozen image resulting from the split-second pulse of the flash. As an alternative to the subject moving, you can intentionally swing the camera.

8 Managing images in Lightroom

Introduction

Just a few years ago, Photoshop was synonymous with photo editing and relatively few people were shooting in raw or thinking much about workflow. That's all changed. Now, many shooters use Lightroom exclusively to manage their workflow and edit images. Lightroom's catalogue database captures previews and metadata so that you can manage images even when they are offline, and you can quickly locate a few shots among thousands in your database.

Lightroom can edit raw, JPEG, TIFF and even Photoshop files. For those who still want the power and precision of editing in Photoshop, Lightroom is one of the best choices for managing images and even doing initial editing before handing them off to Photoshop. When paired with Photoshop, Lightroom handily replaces and improves upon Adobe Bridge and Camera Raw (which come bundled with Photoshop) for most tasks.

In this chapter we'll look at how to get your photos into Lightroom and how to set them up so that you can retrieve that needle-in-a-haystack photo with ease and speed. The last item in this chapter shows how to set up Lightroom to easily move images over to Photoshop for advanced editing.

Workflow and backup

Workflow is really just a fancy word for the order in which you do things, and there is no singular all-purpose workflow. Depending upon whether your aim is to prepare images for a web gallery, share them via email, make a slide show or make prints, your workflow will vary. Whatever your workflow needs, Lightroom is designed to help you move efficiently from the beginning to the end without having to switch between applications. It's also easy to stop in the midst of your workflow and pick up again later. Several possible workflows are shown below.

- Import with keywords
- Import > Add keywords > Develop > Export to JPG
- Import > Rate > Filter by rating > Develop > Export to PDF
- Keyword search > Add to Collection > Adjustment Brush > Create Slide show
- Browse a folder > Filter by Metadata > Export to Web Gallery

As you add more and more images and metadata to your Lightroom catalogue file, its database becomes increasingly valuable in terms of the time needed to recreate it. Lightroom has an option to back up the catalogue file, but it does not back up other valuable Lightroom data. You can use a separate backup utility to back up all of your Lightroom files instead. It is essential that you quit Lightroom before running the backup utility, though. Lightroom keeps some files locked while it is running and the utility will not be able to properly copy the locked files.

Backing up your images is a separate issue from backing up the catalogue and support files. It's a good idea to back up your original master files when you first import them. If you edit in Photoshop, you'll have work-in-process files that are derived from your original master files. It's best to wait until those files are pretty well finalised before backing them up to an archive.

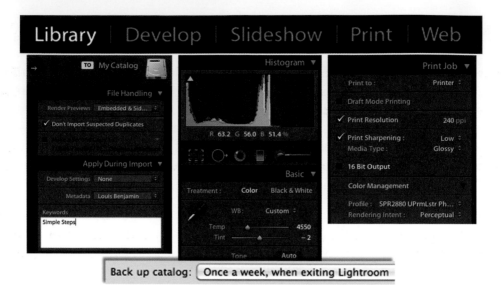

WHAT DOES THIS MEAN?

Metadata: literally data that describes your data. In this case, the data in question are your images. Your camera embeds a lot of metadata (e.g. date and time, shutter speed, aperture, ISO and what lens was used) in your image the moment it is shot. You can add metadata such as keywords, ratings, flags and colour codes at any point in your workflow, from import onwards. When you edit images in Lightroom, your Develop settings are stored as metadata alongside your unaltered original. The Develop settings are the basis of non-destructive editing in Lightroom.

Use the integrated environment

Lightroom is organised around modules that manage different workflow tasks. To move between modules, you can click on the module switcher, which appears at the top right corner of the Lightroom interface.

1 Library: Import and export images, apply keywords, copyright, ratings and other metadata. Synchronise settings or apply metadata to multiple images in the Grid view. Use Loupe, Compare and Survey views to inspect images.

2 Develop: Adjust the appearance of your images, including cropping, red-eye and spot removal, white balance, tone, presence, and black and white conversion. Advanced features include noise reduction, lens corrections, post-crop vignetting, simulated grain and camera calibration.

3 Slideshow: Design the layout and appearance of slides, run ad-hoc slide shows or export to either PDF or video format.

4 Print: Use templates to position and print a single image or organise multiple images into a print package. Sharpen on the fly and manage colour.

5 Web: Use templates to arrange and automatically populate web gallery pages. Export gallery pages to your hard drive or use the built-in FTP (File Transfer Protocol) feature to upload your gallery pages directly to a web server.

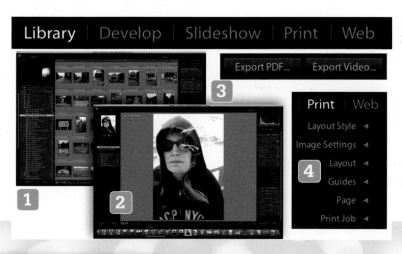

HOT TIP: The Library module has a Quick Develop panel which lets you apply limited adjustments to one or more selected images in the Library's Grid view.

Import

Importing in Lightroom isn't really importing because the images themselves are never stored inside Lightroom. The catalogue database captures only a preview of the image and directory information that points to where the file is actually stored. If you are using the Copy or Move modes, Lightroom does relocate the files that it catalogues, but those files are stored in a standard Windows or Mac OS folder, not inside Lightroom.

That can be confusing because you can unwittingly store the images on one hard drive while the catalogue database resides on another. Being able to carry your catalogue database and only some images on a portable drive is a boon; it's just important to keep in mind where you tell Lightroom to store the actual files.

1 If you're importing from a media card, insert the card into a card reader and connect the reader to your computer.

2 Click Import.

3 The media card should appear on the left side of the dialogue. Or, if you're importing from some other source, use the panel on the left side of the dialogue to select where the files are currently located.

4 Select an import mode (Copy as DNG, Copy, Move or Add).

5 Use the panel on the right to specify a destination, either a folder in the Destination panel when copying or moving or My Catalogue when adding.

6 Optional: Use the Apply During Import, File Handling and File Renaming panels to attach metadata (e.g. your copyright notice, shoot information or default develop settings) to each file as it is added to the database.

7 Optional: Use the Import Preset menu to save your import settings or to apply an existing preset.

8 Click Import to run the process.

The different Import modes are defined as follows:

- When you use the Import command and specify a data card as the source, Lightroom offers only the two Copy modes. It copies the files to the location you specify before adding them to the database and recording the new location.

- Copy as DNG does the same thing as Copy, except it converts the copy to a DNG file.

- When you use the Add mode, you select a folder and Lightroom catalogues the files inside.

- When you use the Move mode, Lightroom copies the files to a new location and deletes them from the previous location. Then it catalogues the files in their new location.

- The Import dialogue has Expanded and Collapsed modes. The dialogue should take up most of the screen. If it doesn't, click the button with a triangle in the lower left corner of the dialogue to show more options.

WHAT DOES THIS MEAN?

DNG: is short for 'Digital Negative'. It is a publicly documented format for raw files that Adobe has developed. It is intended to be more archival than the proprietary formats used by camera manufacturers. For more information, visit Adobe.com/dng.

Add keywords

Keywords are words or short phrases that help you to find your images, regardless of their location within your folder hierarchy. In some software, they're called tags. You can add certain general keywords at the time that you import your photos, but once they are in your library, you can add richer keywords to more narrowly identify images.

1 Tap G to go to the Library module in Grid mode.

2 Click to select one or more images to which you want to apply keywords.

3 Optional: Use the disclosure triangle on the Keywording panel (on the right side) to show the keywording controls. If the Keyword Tags section is collapsed, click the triangle to expand it.

4 Click in the box labelled Click here to add keywords.

5 Enter keywords, separated by commas; hit the Enter key (Return or Enter on Mac) to accept the keywords. The keywords for the currently selected images will appear in the larger box above.

6 To remove a keyword: Double-click or drag inside the larger box to select the keyword you want to remove. Hit the Backspace/Delete key to remove the keyword, then tap Enter/Return to exit the keyword list box.

HOT TIP: Keywords can be a person's name, a description of an event, or category labels. The only limit is your imagination. You can return to add keywords at any time, so you don't have to decide them all at once.

Find by keyword

Once you've entered a lot of keywords, your keyword list will become pretty long. You can use the keyword list to locate a keyword you want and then click to select all images with that keyword, regardless of their location.

1 Tap G to enter the Grid view.

2 Locate the Keyword List panel in the right-hand sidebar and use the disclosure triangle to expand it, if necessary.

3 Type any part of the keyword you're looking for into the search box at the top of the panel. Matching keywords will appear in the list.

4 Hover the mouse pointer over a list item to reveal an arrow at the right edge of the list.

5 Click the arrow to select images with that keyword.

6 The Library Filter panel at the top of the screen will expand, in Metadata mode, with the keyword selected in the left-most column. Matching images will be displayed in the grid.

7 To turn off the keyword filter, click None in the Library Filter bar.

8 To clear the search field in the Keyword List, click the small x on the right side of the box.

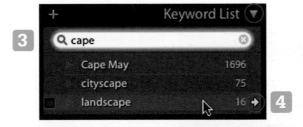

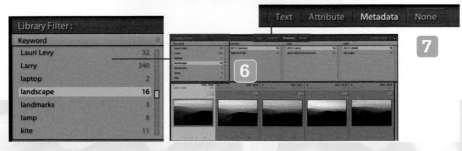

? DID YOU KNOW?

The Text option in the Library Filter bar can look in any searchable field to find the text you're looking for. If you set the Text menu to Keywords, you can locate images by multiple keywords and specify whether any or all keywords must match.

Use ratings

Ratings let you prioritise images on a five-star scale. In the Library module, you can select one or more images in the Grid view (tap G) and tap the 1 to 5 keys to assign a star rating. Select an image and tap 0 to clear the rating. To sort by ratings, select Rating from the Sort menu in the toolbar beneath the thumbnail grid.

Once you've assigned ratings, you can use the Library Filter to select only certain starred images.

1 Click Attribute in the Library Filter bar to activate the attribute filter.

2 In the Library Filter bar, hold down the mouse button on the symbol between the word Rating and the star symbols to reveal a menu. Select the selection criterion (equal to, less than or equal to, greater than or equal to) you wish to use.

3 Click a star in the Library Filter bar to select it and all stars to the left. The selected thumbnails will update.

4 To turn off the filter, click None in the Library Filter bar.

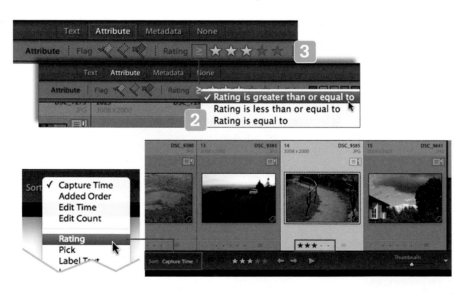

? DID YOU KNOW?

Lightroom has many more options for selecting and organising images. You can assign colour codes and filter by colour code. The Library Filter can filter by Text, Attribute, and Metadata combined. You can save filters as Smart Collections.

HOT TIP: You can also create Collections, which are virtual folders that you can drag files into from any number of actual folders. Within a Collection, you can flag images as a Pick or Rejected, and the flag status of the same image can be completely different in another collection.

Set up Lightroom-to-Photoshop transfer

In order for Lightroom to be able to catalogue and preview your Photoshop files, you'll want to make sure that you save them with the Maximize Compatibility option turned on. Select Photoshop, Preferences, File Handling (Windows: Edit, Preferences, File Handling) from the menu bar. In the File Compatibility section of the dialogue, select Always from the menu labelled Maximize PSD and PSB File Compatibility. Once you set the Maximize Compatibility preference, you probably won't need to change it again.

Working in Photoshop also requires you to address something that you don't have to think about when you're editing in Lightroom, and that's bit-depth and colour space. You use the External Editing preferences to control how Lightroom hands off files to Photoshop. This is a preference that you'll need to change only if your image-editing requirements change.

The steps below discuss the External Editing preferences in Lightroom. The final section of this chapter will cover selecting and transferring images to Photoshop.

1 Select Lightroom, Preferences (Windows: Edit, Preferences) from the menu bar. The preferences dialogue will appear.

2 Click External Editing on the navigation bar at the top of the dialogue.

Photoshop/Edit,
Preferences, File Handling

Lightroom/Edit,
Preferences

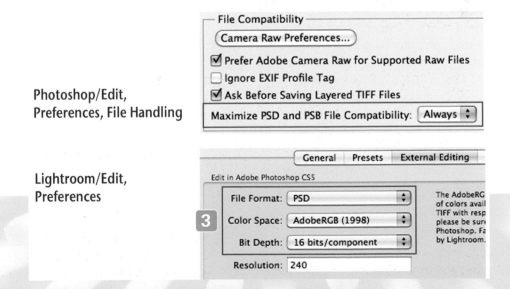

3 Recommended: Select PSD for File Format, AdobeRGB (1998) for Color Space and 16 bits/component for Bit Depth. Don't worry about resolution – you'll adjust that when you're ready to print.

4 Close the Preferences dialogue.

HOT TIP: The External Editing preferences shown here are excellent choices for general-purpose editing. ProPhoto RGB is a bigger, richer colour space that can potentially print more colours, but it must be edited in 16-bit mode. Adobe RGB works well in both 8- and 16-bit mode. Lightroom also suggests that TIFF is more efficient with metadata updates, but PSD has a few other advantages over TIFF.

ALERT: If you're having trouble importing older Photoshop files into Lightroom, they were probably saved with the Maximize Compatibility option turned off. Make sure the option is on, open each file and use Save As to replace the older files, then try importing again.

Edit images from Lightroom in Photoshop

You can transfer a file to Photoshop from Lightroom for advanced editing from the Library, Develop, Slideshow and Print modules. You can transfer files from both the Grid and Loupe views in the Library module.

Lightroom will normally track and catalogue the files that you transfer to Photoshop. The edited version will appear in the Library (even stacked with the original) when you save it. It's crucial that you use Save (not Save As) when you use this option, otherwise Lightroom will lose track of the edited version.

To transfer a file from Lightroom to Photoshop, control-click (Windows: right-click) on the image to display a menu and select Edit In, Edit in Adobe Photoshop CS5 from the menu.

If you're editing a raw file, it simply opens in Photoshop with the Lightroom adjustments applied. If you're opening a JPEG, TIFF or Photoshop file, you have a choice to make:

1 Edit a Copy with Lightroom Adjustments: Apply the Lightroom adjustments to a copy of the file. Lightroom will create a placeholder in the catalogue for the file when you save it. Do not use Save As or you'll break the link back to Lightroom.

2 Edit a Copy: Duplicate the original version of the file and do not apply the Lightroom adjustments. Lightroom will create a placeholder in the catalogue for the file when you save it. Do not use Save As or you'll break the link back to Lightroom.

3 Edit Original: As it says, you're altering the original file. Once you use the Edit in Photoshop command and save the file, it will appear in your Lightroom catalogue. You can use the Edit Original option to continue working on the same file. The preview in Lightroom will update when you resave the file. You can also use this option if you want to edit the file without keeping a new thumbnail in the catalogue. Use Save As to keep from overwriting the original.

Once you select an option in the What to Edit dialogue and click the Edit button, the image will appear in Photoshop. When you use File, Save from Photoshop, the file will appear in the catalogue.

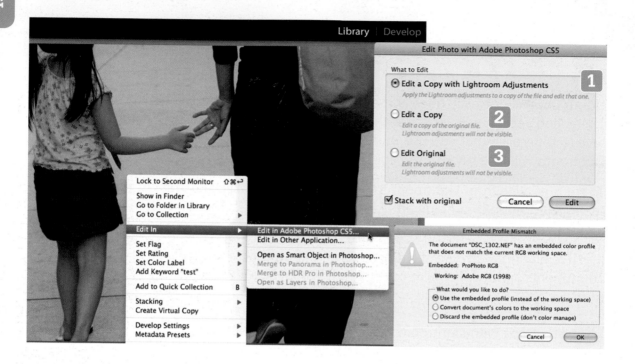

ALERT: If the colour space of the file you transfer from Lightroom does not match the colour space you selected in the Edit, Color Settings dialogue, you may see a dialogue asking if you want to convert to the working space. Since you selected your optimal colour space in Lightroom, you should select the Use embedded option.

9 Editing and printing in Lightroom

Introduction

Lightroom's Develop module is just a keystroke away from the Library module. Tap the D key and you move smoothly from organising to developing images. The heart of the Develop module is the Camera Raw engine, which processes not just raw files but JPEG, TIFF and even Photoshop files as well.

Lightroom's non-destructive editing capability is what sets it apart from pixel-editing software such as Photoshop, Photoshop Elements and PaintShop Pro. As you edit what looks like your image inside Lightroom, you're really adjusting a preview. Lightroom is managing a recipe (the Develop settings) that details how to create the image you're seeing in the preview. When you finish making your edits, the settings are stored along with your untouched original. You can change the settings at will, or throw away all the settings and start again. You can also create virtual copies, which allow you to process as many variations of the image as you like.

When you decide to export a JPEG, use the image in a PDF or webpage, or edit the image in Photoshop or some other external editor, Lightroom 'bakes' a fresh copy by applying the recipe to a copy of the master file. Lightroom's flexible export capabilities are smoothly integrated into the Library module – just tap G to return to the Library module in Grid view. The Slideshow, Print and Web modules are all a click or keystroke away, too.

Use the Develop module

You can use the non-destructive editing tools in the Lightroom Develop module to enhance your images. The Develop module is built on the same processing engine as Camera Raw (a plug-in for Photoshop and Bridge), but it has an enhanced interface. This section is an overview of the features in the module. Some features will be covered in greater detail later in this chapter.

The Develop module uses the same format as the Library module, with three central columns, plus the Module switcher at the top and the Filmstrip at the bottom. The left column is for navigating and applying or undoing groups of settings. The central column shows different views of the image, with a toolbar at the bottom. The column on the right contains the Histogram and development controls. Each panel in the left and right columns will expand or collapse when you click its disclosure triangle.

You don't have to switch back to the Library module to navigate between images – you can select an image to edit by clicking in the Filmstrip or using the Next or Previous arrows in the toolbar. The various components are:

1 Module switcher

2 The Navigator panel

3 Presets, Snapshots and History – change settings with a single click

4 Collections – load sets of images into the Filmstrip

5 Loupe view

6 Before and After views

7 Previous and Next photo

8 Zoom

9 Configure toolbar

10 The Histogram

11 Tool strip – Crop & Straighten, Dust and spot removal, Red-Eye Correction, Graduated Filter and Adjustment brush

12 Adjustment panels.

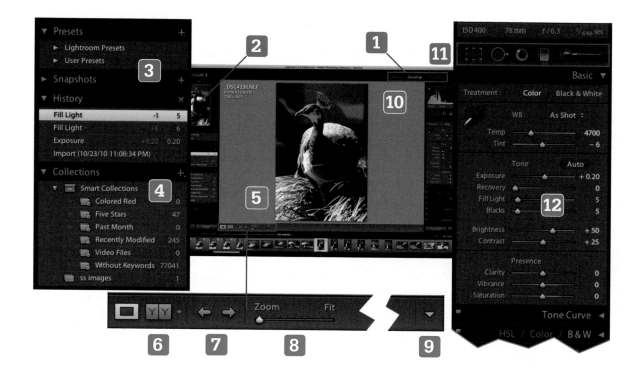

HOT TIP: The Quick Develop panel in the Library module manages the same adjustments as you see in the Develop module, but the controls offer only coarse adjustments. Its main advantage is that you can stay in the Library module.

Use Develop Presets

Develop Presets can save you lots of time processing images. They are packaged sets of adjustments that you can apply with a single click, and you can preview the effect of Presets in the Navigator panel before you click. Once you have applied a Preset, you can adjust the settings and then save your variation as a User Preset.

1 Open the Navigator panel (use the disclosure triangle to expand it).

2 Hover the cursor over an item in the Presets list to see a preview in the Navigator panel.

3 Click a Preset to apply.

4 Use Command/Ctrl + Z to undo.

5 Click the + (plus sign) at the top of the panel to create a new user Preset.

6 To remove a user Preset, control-click/right-click and select Delete from the menu.

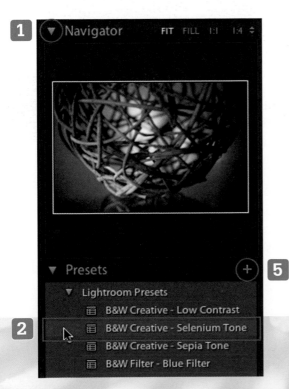

? DID YOU KNOW?
You can find downloadable presets for Lightroom on the Web. onOne Software offers Perfect Presets, a free collection of more than 190. To download, visit www.onOneSoftware.com/products/perfect-presets-lightroom/.

HOT TIP: You can apply a Develop Preset to one image and then use the Synchronize command in the Library module to apply it to several images at once. You can also apply Develop Presets to images as you import them into Lightroom.

Adjust white balance

If your camera has guessed the wrong white balance or you selected the wrong setting, you can still correct it in Lightroom, if you shot raw. In some cases, you can even fix JPEG files. You can also use the white balance controls creatively to intentionally induce warm or cool colour casts.

Once you have set the white balance in one image, you can synchronise those settings to other images by copying the settings and pasting them one image at a time, or by using the Sync command with groups of images.

An advanced technique for getting accurate white balance involves shooting a test frame with a neutral grey target such as the x-Rite ColorChecker Passport or the Whi-Bal card to record the colour temperature of the light you're working with. When you process your images in Lightroom, you can then sample the white balance from the test frame and synchronise the white balance setting of the rest of your shots to it.

1 To manually adjust your image: a) If your photo looks bluish, you can move the Temp slider towards the yellow to neutralise it and vice versa; b) Use the Tint slider to compensate for green (or magenta) colour casts. This can occur if you shot under fluorescent light, or even under shade trees.

2 Use the white balance Presets in the WB menu to neutralise Daylight, Tungsten, etc.

3 To sample white balance: Click the white balance dropper in the panel to activate it and then click on something in the image that is supposed to be neutral grey. It could be a neutral grey target designed for that purpose, or anything that seems as though it ought to be neutral.

4 Use colour temperature creatively: a) Move the Temp slider towards the blue or yellow to intentionally cool or warm your image. b) Use the WB cross-purpose for creative effects. You can use the Daylight, Cloudy or Shade White Balance presets with tungsten lights (conventional light bulbs) to induce a warm golden colour. Or use the Tungsten Preset with outdoor scenes to induce a cool blue cast. c) Click the

white balance dropper on something that is warm-toned to cool the image (higher Temp selection), or click on something that is cool-toned to warm the image.

5 Copy and paste to apply the same settings to other images: Click the Copy button to open the Copy Settings dialogue. Tick the boxes next to the settings you want to copy and click Copy. Then you can click an image in the Filmstrip or use the toolbar arrows to navigate to another image. Click Paste to apply the settings you copied.

6 You can also synchronise white balance settings via the Filmstrip:

- Select a group of images in the Filmstrip (including the image you want to copy the settings from) by clicking one image to select it and then holding the shift key and clicking on another to select it and all images between. Hold down Command/Control and click individual images to select or deselect them.

- Activate the image that you want to copy settings from by holding down the Option/Alt key and clicking one of the selected images.

- Click the Sync button at the bottom of the right-hand panel to open the Synchronize Settings dialogue. It looks and works like the Copy Settings dialogue described above.

- Tick the boxes to specify which settings to copy, then click Synchronise.

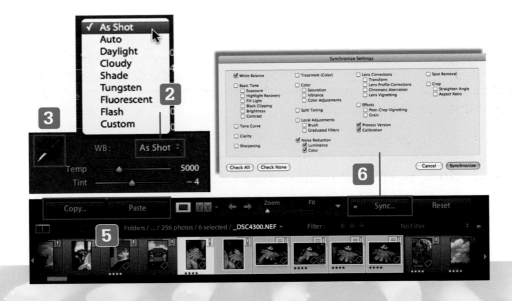

Use the Histogram

The Histogram panel allows you to view and adjust the distribution of tones in your image. It can warn you about clipping and indicate when details in the shadows or highlights may not print. The triangles appear grey when no clipping is occurring. A colour such as red, green, blue, yellow, magenta, etc. indicates that one or more channels are clipping.

1 Hover the cursor over the warning triangles in the upper corners of the graph area to see regions in the image that are clipped to pure black or pure white. Clipped blacks are shown in blue and clipped highlights are shown in red.

2 Click the warning triangles to lock them on or switch them off. A white box outlines the triangle when the indicator is on.

3 Hover the cursor over regions of the graph area to see which slider in the Basic panel controls those tones. Left to right, those regions are Blacks, Fill Light, Exposure and Recovery.

4 Drag horizontally in the graph area to adjust the corresponding slider in the Basic panel.

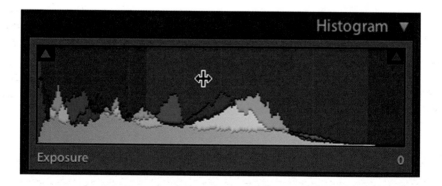

HOT TIP: There is no one perfect shape for the Histogram graph. A high-contrast image may have two peaks near the ends of the range, while a high-key image is likely to have a single hump towards the right and a low-key image may cluster most of its tones near the left.

Adjust highlight and shadow clipping

The Blacks and Recovery sliders help you to address clipping in the shadows or highlights of an image. You can think of your camera as being able to handle about a 10-stop difference between the darkest and brightest intensities of light in any scene. But the light that we see can have bigger intensity differences than that. When that happens, you can adjust your camera so that either the details of the highlights or the shadows fall within that 10-stop range. Any brightness levels that fall outside the range are clipped – they're simply recorded as the lowest or highest available value. When this happens, we say that the highlights are blown or the shadows are clipped.

The Blacks and Recovery sliders control clipping in the darkest and brightest tones in your image, respectively. While they can't create detail that doesn't exist, they can minimise the effect of clipping.

You can use the sliders alone, or you can turn on the highlight and shadow warning indicators in the Histogram panel to show where clipping is occurring inside the image as you adjust it. The lighting situation and the exposure will determine whether you can completely eliminate the effect of clipping.

HOT TIP: Sometimes only one or two of the Red, Green and Blue colour channels gets clipped during exposure. That means highlight detail information is still available in any channel that did not clip. When that happens, Lightroom can recover some highlight detail.

1 Drag the Blacks slider or drag the left edge of the graph inside the Histogram to adjust the Blacks level.

2 Drag the Recovery slider or the right edge of the Histogram graph to adjust the Recovery setting.

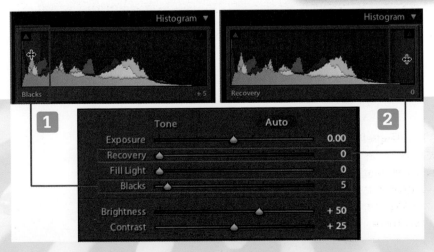

Adjust tone

The Exposure and Fill Light sliders control tones in the middle of the tonal range. You can adjust the tones by dragging the sliders, or simply drag inside the Histogram graph.

1 Fill Light lightens or 'opens' details in the shadows.

2 Exposure moves a broad range of middle tones to either brighten or darken the image. You can increase the exposure to a level that makes the overall image look correct, and rein in the highlights with the Recovery slider.

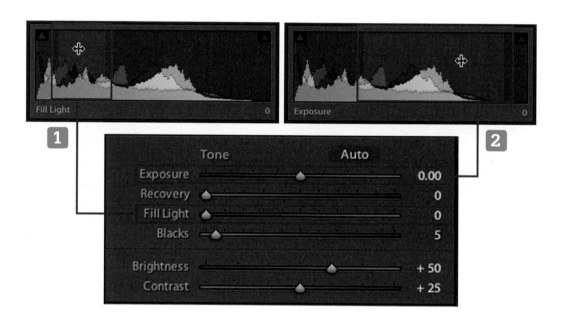

ALERT: Be careful adjusting Fill Light. Over-lightening the shadows can bring out a lot of noise.

Adjust brightness and contrast

The Brightness control lightens or darkens the image. It moves a broad group of tones together and is best applied after you have adjusted Exposure, Recovery and Blacks.

The Contrast control targets the middle tones in the image. As you increase contrast, it darkens the tones at the darker end of the range and lightens the tones at the lighter end. Decreasing contrast works in the opposite way.

If you boost brightness or contrast in the extreme, you may want to readjust Exposure, Recovery or Blacks afterwards.

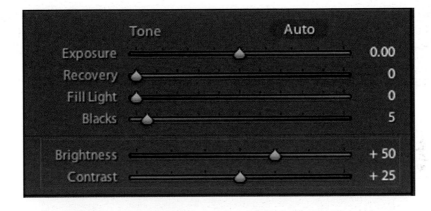

SEE ALSO: It can often be useful to boost the brightness and contrast of just some parts of the image. The Adjustment brush, covered later in this chapter, allows you to do just that.

Adjust presence

The Clarity, Vibrance and Saturation controls make up the presence settings. It is best to adjust them in sequence from top to bottom.

The Clarity control has a sharpening effect. When you increase Clarity, it looks for edges and enhances them. It also increases midtone contrast and saturation. Using a negative value for the setting does the reverse, reducing contrast and softening detail.

Zoom in to 100% to check the clarity setting. At some point, haloes will become obvious around the edges of some elements of the image. Reduce the setting until the haloes are no longer evident.

Vibrance is essentially a smart version of the Saturation control. Both affect the purity and intensity of colours. For example, pastels are desaturated tints of more pure hues. Increasing the saturation of pink turns it increasingly red. The Saturation control is a blunt instrument that simply boosts the saturation of colours in the image with no concern for what those colours are. The results can be pretty garish. The Vibrance control protects skin tones and highly saturated colours. Thus, it boosts the saturation of colours that are not skin tones and those that do not have much saturation, but adds little or no saturation to other colours. A good strategy is to adjust the Vibrance setting first and add a pinch of Saturation only if needed.

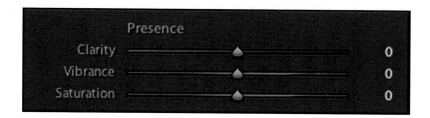

 HOT TIP: Clarity is one of the settings that you can apply with the Adjustment brush, making it an excellent tool for retouching in Lightroom. To make key elements of your image 'pop', select a positive value and apply the brush to the areas you wish to enhance. Apply the brush with a negative value to smooth skin.

Apply local adjustments with the Adjustment brush

Lightroom's Adjustment brush tool allows you to locally apply Exposure, Brightness, Contrast, Saturation, Clarity, Sharpness and fields of colours to an image. Up to this point, the tonal adjustments we have looked at (e.g. Exposure, Contrast and Clarity) have all been applied globally – equally across the entire image. Local adjustments are selectively applied to specific areas of an image instead. Two examples are dodging (to lighten) and burning (to darken).

Once you define a set of adjustments in the Adjustment brush panel, you apply them inside a mask that you paint onto areas of the image. You can reshape the mask and the area that it covers at any time by painting or erasing. You can also revise the adjustment settings for the mask or delete it altogether. You can overlap masks to double up or combine different effects. The panel defaults to the 'A' brush, but you can also define and paint with a separate 'B' brush, if you like.

1 Tap K or click the icon in the Tool Strip to activate the brush.

2 In the Effect section: Make an initial adjustment to the effect, so you'll be able to see where you are applying it. (You'll make the final adjustment later.)

- Double-click the label to reset any adjustment to zero or clear the current colour.

3 In the Brush section: Set the Size, Feather, Flow and Density of the brush.

- Feathering creates a soft edge to the mask that generally blends better.
- Lower Flow and Density settings give you more control to gradually build up the effect as you apply it.

4 Paint in the image to apply the effect. Your first stroke places a pin in the image, which acts as your control point for the mask.

5 To reveal or select a mask: Hover the cursor over the pin to reveal the mask as an overlay. Click the pin so that a black dot appears inside it to select.

6 To add an additional effect: Click New to begin a new mask. Adjust the settings and paint in the image. A new pin will be added where you begin your first brush stroke.

7 To adjust the settings of the selected mask: Move one or more sliders in the Effect section, or hold down the mouse button on the pin and drag right or left to move the affected sliders.

8 To remove part of a mask: Click Erase in the Brush section and then adjust Size, Feather and Flow as needed. Brush in the image to remove the mask and its effects. When you've finished, click A or B in the Brush section to return to your previous brush.

9 To delete a mask: Click a pin and hit the Delete/Backspace key.

10 Toggle all brush adjustments on and off with the switch icon at the lower left corner of the panel or click Reset to remove all masks.

11 Click Close to hide the Adjustment brush panel.

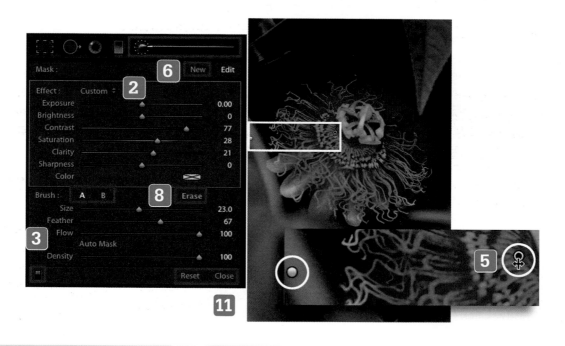

HOT TIP: The Effect and Brush sections have disclosure triangles that can show or hide some of the slider controls.

Crop

When you crop, you create a new composition. Although a lot of people simply crop to remove things from the shot, a more effective way is to reshape the framing of the shot so that the new composition has its own integrity. Lightroom shows you a crop overlay and provides a set of standard crop shapes to help you.

1 Tap R to activate the Crop & Straighten panel, or click the icon in the tool strip beneath the Histogram. The current crop area will appear, showing an overlay with eight handles around the edges.

2 Optional: Use the Aspect menu to specify the shape of the crop. Try different proportions to find a shape that gives the best coverage.

3 Optional: A closed lock icon opposite the Aspect icon indicates that the crop area will maintain its proportions. Click the lock icon to unlock it and alter the shape of the crop arbitrarily.

4 Drag one of the handles to change the size of the cropped area.

Or

1 Click the Crop Frame tool icon in the panel. The icon will disappear from the panel and the cursor will turn into the icon with a crosshair. Drag the crosshair inside the image to define a new crop area. You can adjust the shape of the crop with the handles once you release the mouse button.

2 When the cursor is inside the crop rectangle, it becomes a hand tool. Drag with the hand to reposition the image area beneath the crop.

3 You can use the crop overlay to align elements inside the frame. The default overlay is a Rule of Thirds grid. Press the letter O key to activate the overlay and repeat to cycle through other overlays, including Golden Section, diagonals and the Golden Spiral. (The Fibonacci Spiral is an approximation of the Golden Spiral.) If you want to flip the orientation of the overlay, press Shift + the letter O key.

4 Click Reset to remove cropping from an image.

5 Click Close at the bottom of the panel or Done in the toolbar to complete any editing you have done to the cropping.

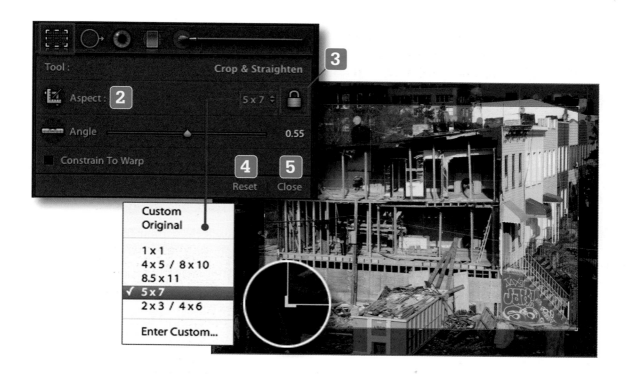

ALERT: Cropping reduces the resolution of an image.

Straighten

Straightening is incorporated into the Crop tool in Lightroom. There are several methods available. You can straighten arbitrarily or by measuring. You can straighten only, or straighten after making an initial crop.

1 Tap R to activate the Crop & Straighten panel, or click the icon in the tool strip beneath the Histogram. The current crop area will appear, showing an overlay with eight handles around the edges.

2 When the cursor is outside the bounds of the crop area, it will change to a bent arrow. Drag to rotate the image. A grid overlay will help with visual alignment and the angle of rotation will appear in the panel.

3 Alternatively, you can move the angle slider or type a value into the angle field to adjust the angle.

4 To set the angle by measurement, click the level icon on the left side of the panel. The icon will disappear from the panel and the cursor will change to a crosshair with a level nearby. Drag the crosshair to indicate a line that should be either horizontal or vertical. When you release the mouse button, the image will straighten.

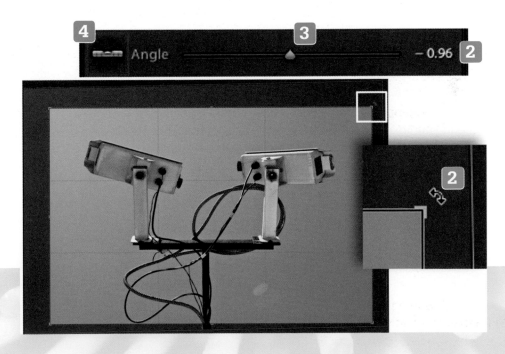

Remove noise

The Noise Reduction controls appear in the Detail panel, beneath the Sharpening controls.

Digital noise can be a visual nuisance. It comes in two forms. Luminance noise appears as random variations in brightness that resemble film grain. Most people tolerate more luminance noise than colour noise, which appears as flecks of saturated colour in a random pattern.

A side effect of noise reduction is a loss of detail, so you can use the Detail and Contrast controls to help to preserve some detail that would otherwise be lost. Zoom in to 1:1 or closer to see the effects of noise reduction more clearly.

1 Move the Luminance slider to begin removing luminance noise. The Detail and Contrast sliders will become active as soon as the amount is greater than zero. As you increase the setting you may notice the image beginning to soften. That is normal. Increase the setting until you are satisfied with the overall result.

2 Adjust the Detail and Contrast settings as needed to offset some of the softening produced by the Luminance setting.

3 Adjust the Color slider to apply colour noise reduction.

? DID YOU KNOW?

Noise often appears in the shadows before it is visible anywhere else in your image. Sometimes, you can avoid noise by shooting differently. Shooting at high ISO settings with a cropped-sensor camera can induce noise. You can also get noise as a side effect of trying to lighten detail in the shadows too much.

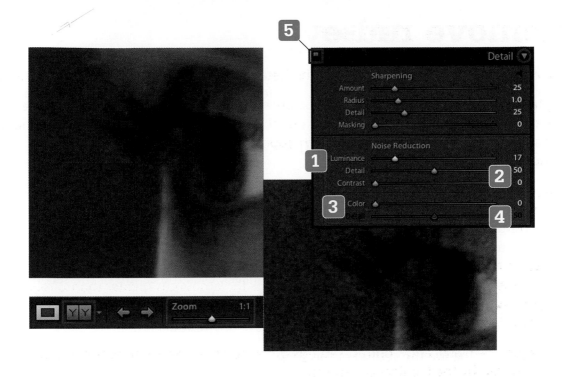

4 Adjust the Detail slider as needed to compensate for any softening.

5 Toggle the On/Off switch in the top left corner of the Detail panel to compare results, or you can use the Before/After view in the toolbar beneath the image.

Remove red-eye

Red-eye can be a common problem with on-camera flash, especially in dark rooms. The red-eye tool is very easy to use and an effective way to make those troublesome eyes look normal.

1 Zoom in to show the eyes up close. Use the Zoom slider in the toolbar and the Navigator panel to position the eyes.

2 Click the Red Eye Correction icon in the strip immediately below the Histogram.

3 Place the cursor at the centre of the eyes and drag downwards and outwards until the markers surround the eye, then release the mouse button.

4 Unless the other eye appears considerably smaller, click the centre of the second eye to place a second red-eye removal without having to resize.

5 Optional: Adjust the Pupil Size slider to remove any residual red.

6 Optional: Change the setting of the Tool Overlay menu in the toolbar beneath the image to hide the red eye circles. Click to toggle the On/Off switch in the lower left corner of the Red Eye Correction panel and evaluate the red-eye reduction.

7 Optional: Click Reset at the bottom of the panel to clear the corrections.

8 Click Close in the panel or Done in the toolbar to commit your adjustments.

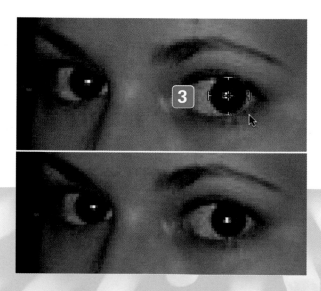

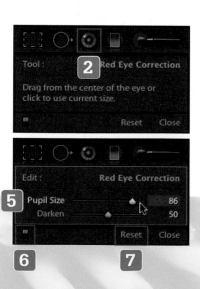

Heal and clone

Lightroom removes spots by covering them with data copied from another part of the image. You encircle the area you want to repair and then specify where to get data to cover the spot with. You can specify whether to use the healing or cloning method for each spot that you remove. Cloning simply duplicates the source data to cover the target spot, whereas healing tries to blend the data into the area surrounding the spot you're covering. You can also vary the opacity (especially when cloning spots) to get a better match.

Before you begin, use the Zoom control in the toolbar and the Navigator panel to magnify the area you want to repair. Press the Q key or click the Spot Removal icon in the tool strip to activate the tool. Follow the steps below to repair as many spots as you need.

1. Click on a spot that you want to remove (the target). A circle will cover the spot and a second circle will appear adjacent to it.

2. Optional: Use the size slider or drag the edge of the circle (the mouse pointer will change to a double-headed arrow with a bar in the middle) and resize it to cover the spot.

3. Optional: Click a circle to select it. Click Clone or Heal to change the method of repair or hit Delete/Backspace to remove it.

4. Drag the second circle to the area of the image that you want to copy (the source). When you release the mouse button, an arrow will point from the source circle to the target circle.

5. Optional: Drag either circle from the centre (the mouse pointer looks like a hand) to reposition it. You can also click on a circle and use the arrow keys for small movements.

6. Optional: Select a Tool Overlay option (Auto is the default) from the menu in the toolbar beneath the image window. This allows you to hide the circles and evaluate the repair more easily.

7 Optional: Toggle the On/Off switch at the lower left edge of the tool controls to see how the repair is working.

8 Click Close at the bottom of the Spot Removal panel or Done at the right edge of the toolbar to complete the process.

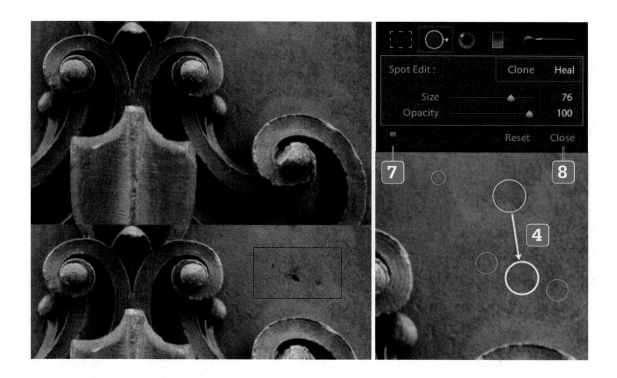

 HOT TIP: If you decide later that you don't like the way the spot repairs worked, you can always reactivate the Spot Removal tool and click Reset to clear all spot repairs.

Export images

You can export files from the Library module of Lightroom in JPEG, TIFF, PSD (Photoshop), DNG and the original format of the selected file(s). Exported files can be written to your hard drive or directly to a CD/DVD. The Export dialogue has several sections that can be expanded or collapsed by clicking on the disclosure triangle for the section. To begin the export process, select one or more photos in Grid view and then click the button labelled Export... in the lower left corner of the window.

1. If you are exporting to a hard drive, use the Export Location section to specify where your files will be saved.

2. Optional: Use the File Naming section to rename the file as needed.

3. Use the File Settings section to specify the file format, colour space and bit depth. Additional options will appear based upon your selection from the Format menu.

 - JPEG is only 8-bit. Select a quality level. A setting of 90 produces a file that is roughly half to one-third the size of the 100 setting, and it will be difficult to see the difference.

 - TIFF has the option to use lossless ZIP compression. Files saved with this option are smaller but take more time to open and save. ZIP compression will not degrade your image the way that JPEG compression does.

 - If you save in DNG format, you'll have the option to choose your compatibility level, what size preview to embed and whether or not to embed the original raw file.

4. Optional: In the Image Sizing section, tick the box marked Resize to fit and specify the dimensions and resolution to use.

5. Optional: In the Output Sharpening section, tick the box marked Sharpen For and select the media type and amount of sharpening from the menus.

6. Optional: In the Metadata section, tick Minimize Embedded Metadata to prevent keywords, camera data, etc. from being included in the exported file.

7 Optional: Use Watermarking to place an overlay containing your copyright notice, etc. onto the photo.

8 Optional: Use the Post-Processing section to specify how the files will be handled after they are exported. With this feature you can set Lightroom to start a new email message and attach the exported files.

9 Optional: Click Add in the lower left corner of the dialogue to save your export settings as a Preset.

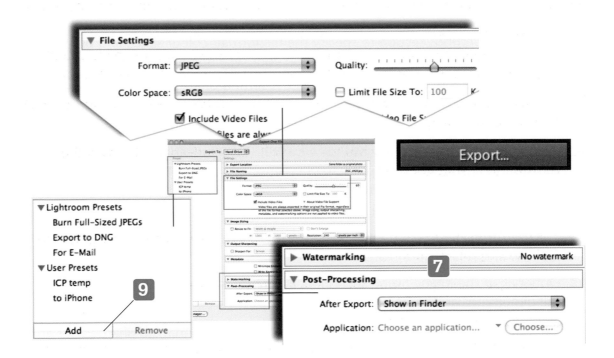

Set up a slide show

The tools in the Lightroom Slideshow module are robust. To build a slide show, you'll first select and sequence your images. Then you'll select an initial format for your slide show and modify it with the toolbar. Finally, you'll refine your slide show via the panels on the right side.

Begin setting up

1. In the Library module Grid view, select images to include in your slide show, then switch to the Slideshow module.

2. To allow ordering, press the mouse button down on the plus sign (+) at the top of the Collections panel to show a menu and select Create Slideshow.

3. In the dialogue that appears, tick the box labelled Include selected photos, and name and save the set. Placing the files into a set allows you to resequence them.

4. The set starts out with all photos selected in the Filmstrip. Use Command/Ctrl + D to deselect the images.

5. Click a thumbnail in the Filmstrip to preview it. Drag individual photos in the Filmstrip to change their order.

Begin formatting

6. Use the Template Browser and Navigator panel on the left side of the window to preview and select a template.

7. Choose Selected Photos from the Use menu in the toolbar.

8. Use the Rotate tool as needed.

9. Click the Add Text tool (ABC icon) to activate it and place metadata or static text into the template. Type static text into the box that appears or select an item from the menu to add a metadata Preset or open the Text Template Editor.

10 Drag the text object from its centre or by the handles to reposition or resize it as needed.

Refine your slide show

11 Use the Titles panel to add intro and ending slides. (This is optional.)

12 The playback controls apply only if you save your slide show as a video. Tick the box labelled Soundtrack and click Select Music to add an audio track. Once the soundtrack is selected, you have the option to click a button to time the slides so that they fit the length of the audio.

13 When you're happy with the design of your slide show, you can click the plus (+) icon in the Template Browser on the left to save the set-up as a template for future use.

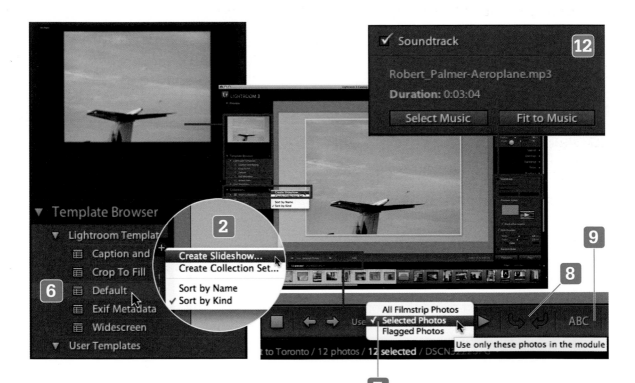

HOT TIP: If you want to use music from your iTunes library, control-click/right-click on a song and choose Show in Finder/ Show in Windows Explorer from the menu. From there, you can copy the file to another location to make it easier to work with.

Export a slide show

You can save your slide show as an MP4 movie file or as a more limited PDF document compatible with Adobe Acrobat and Apple's Preview from the Slideshow module in Lightroom. The Export PDF and Export Video buttons are at the bottom of the panel on the left.

When you make a PDF slide show, the PDF player sets the playback options of the slides. Slides are automatically converted to sRGB when the slide show is exported. They have no soundtrack and no random-order option.

To begin creating a PDF file

1 Click Export PDF. A Save As dialogue will appear.

2 Name your slide show and specify where it will be saved.

3 Use the Quality setting to manage JPEG compression. Lower quality creates a smaller file.

4 Enter a width and height into the boxes, or use the Common sizes menu to set the space that the slides will be sized to fit.

5 Optional: Tick the box Automatically show full screen.

6 Click Export to create the slide show.

To begin creating a video file

7 Click the Export Video button. A Save As dialogue will appear.

8 Use the Video Preset menu to determine pixel size and frame rate.

9 Click Export to generate your file.

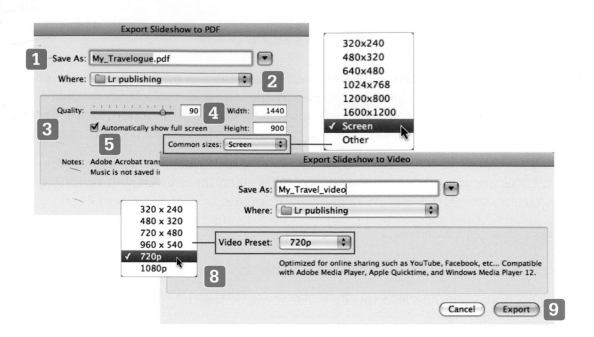

HOT TIP: Once you set up a slide show, you can play it in Lightroom without exporting. Click the Play button in the toolbar of the Slideshow module to start the show. You can also use the Play button in the toolbar of the Library module. The currently selected photos will be shown using whatever slide show template is current.

Print

Lightroom's printing module can colour-manage printing for maximum colour control. It also gives you a sophisticated and flexible tool for printing multiple photographs. Using templates, photos can be printed on individual sheets or combined onto a single page. Click on Print in the upper right side of the Lightroom window to switch to the Print module.

This example shows printing on the Epson 2880 printer from a Mac, but operating system dialogues and print drivers vary. Also, Lightroom's Page Setup and Print Settings buttons are combined into one on Windows. Regardless of your computer and operating system, the same principles apply, even though your screens may be different on your computer.

1 Use the template browser on the left side of the window and click to select a template, e.g. Maximize Size, (1) 8 × 10, or 5 × 8 Contact Sheet.

2 The Filmstrip will retain the selection you make in the Library module, or you can use the Collections panel and Filmstrip to select photos to print.

3 Click the Page Setup button on the lower left to open the operating system's page set-up dialogue. Specify your printer and paper format, then click OK to close the dialogue. (In Windows, choose a page size from the Size menu.)

4 Click Print Settings on the lower left side of the window to open the print driver dialogue and navigate to the Color Settings section.

- If Lightroom is managing colours, choose Off (No Color Adjustment) from the Color Settings menu.

- If the printer is managing colours, choose a colour space that matches your printer's capabilities. Most can manage sRGB, but some can also manage Adobe RGB.

- Select print quality. High speed is optional. Click Save to close the dialogue.

5 Use the Layout panel on the right side to customise a pre-selected template and control the size and position of the image on the page.

6 Go to the Print job panel at the bottom of the panels on the right side. You may need to scroll down and use the disclosure triangle to see the controls.

7 Recommended: Leave Print Resolution ticked and set to 240ppi.

8 Set print sharpening according to your tastes.

9 In the colour management section of the panel, select either Managed by Printer, a colour profile, or Other from the menu.

- Use Other to manage the colour profiles that appear in the colour management menu. Tick or untick items to add or remove them from the menu and then click OK.

10 If Lightroom is managing colours, select Perceptual under Rendering Intent to maintain tonal transitions. Or select Relative to minimise colour shifts, though it has a greater risk of problems with tonal transitions in gradients such as skies and clouds.

11 Click Print One to send the job to the printer, or click Print to revisit the printer driver dialogue from step 4 before sending the print job to the printer.

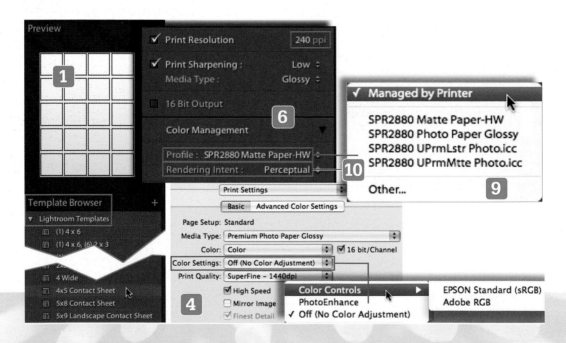

HOT TIP: You can save any customisation that you've done in the Print module as a template. Click the plus sign (+) at the top of the template browser panel to open a dialogue to name and save your settings.

10 Basic video editing

Introduction

Today, many of the bestselling digital SLR cameras feature 1080P high-definition video capabilities, so it's impossible to write a book about using dSLRs without giving some attention to video. These words are being written almost three years to the day after Nikon announced the first dSLR with HD video (the D90). Just two weeks later, Canon announced its updated 5D Mk II with superior video capabilities, and in the short time since, the idea of dSLR video has spread like wildfire, spawning a substantial aftermarket.

A significant part of the excitement of shooting HD video with an SLR comes from the differences between the designs of dSLR and HD video cameras. There are also important differences between SLR lenses and video lenses. With few exceptions, any of the lenses discussed in Chapter 5, including Lensbabies, can be used with your dSLR in video mode. This opens up a whole range of creative possibilities that are largely unavailable with standard video cameras. The larger sensor in dSLR cameras also makes it possible to make movies in low light that surpass the performance of standard video cameras.

As exciting as these new capabilities are, shooting video with a dSLR is really a completely different discipline from shooting stills. The choices of equipment, lighting and even shooting technique for video are enough to fill several books. So given the scope of this book, the ambition of this chapter cannot be so all-encompassing. We'll leave the ins and outs of shooting video with a dSLR to another book in the *Simple Steps* series and focus instead on what happens after you have shot raw footage with your camera.

Video editing is what transforms raw camera footage into storytelling. Your footage isn't really a movie until you've refined it and converted it to a format that is better suited for sharing via websites, DVDs, etc. That's where video-editing software comes in. This chapter will look at the basics of importing and editing video in Adobe Premiere Elements 9, the bestselling video-editing software today. Its low cost, solid feature set and availability on both the Mac and Windows platforms make it an excellent entry-level tool. More advanced video-editing applications include Adobe Premiere and Final Cut Pro from Apple. The advanced software has more features and capabilities, but Premiere Elements is designed around the same basic principles.

A look at Adobe® Premiere® Elements

Within Premiere Elements, you can assemble video-only footage, audio clips, movie clips (which contain both video and audio), still photos, graphics, text and effects into a finished movie. When you put together a movie project in Premiere Elements, all editing is performed non-destructively, meaning the software does not copy, move, delete or alter your original files in any way.

Once you shoot footage with your camera, you can transfer it to your computer by a number of means, including an optional feature within Premiere Elements. Like the Import function in Lightroom, the Get Media feature in Premiere Elements does not actually bring your video footage (or other assets) into the software. Instead, it records references to the content and manages those references. This is often referred to as linking to the files, and your project files contain only links and references back to the original source files. Because of this, project files are relatively small.

The editing process can involve any of the following:

- Arrange clips into a rough cut
- Trim unwanted video
- Add transitions
- Add video and audio effects
- Add audio, i.e. music or narration
- Add graphics and text.

The main window of Premiere Elements consists of three panels:

1. *Monitor panel.* This contains VCR-style controls for playing back your project. You also use it to trim the ends of video or movie clips.

2. *Tasks panel.* This is divided into four workspace tabs (Organize, Edit, Disc Menus and Share), which are further subdivided into views. Under the Organize tab, you'll use

the Get Media and Project views most. Get Media allows you to reference media on your hard drive. Organize keeps track of the media that you have brought in and allows you to include them in your project. After you edit your movie in the MyProjects panel, you'll return to the Tasks panel and use the Share workspace to export your finished movie in different formats.

3 *My Projects panel*. Each movie you create starts out as a project. You'll use either the Sceneline or the Timeline view within this panel to structure and edit your project. The Sceneline is designed for simplicity and ease of use, with first-time users in mind. It has several limitations, and you're likely to graduate to the Timeline view after making a few movies.

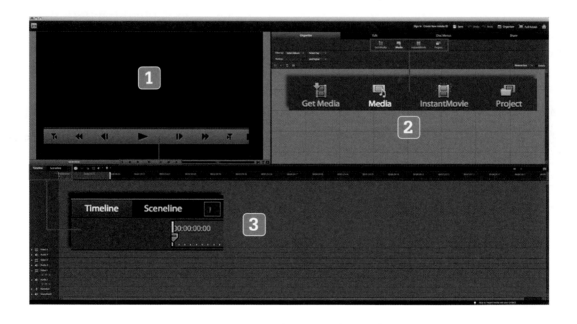

HOT TIP: Premiere Elements lets you share your movie in a number of formats for web and handheld devices. For example, you can upload movies directly onto YouTube. You can also create DVDs and Blu-ray discs, complete with menus.

Start a new project

In Premiere Elements, you create projects to manage your movie-making assets. You'll start each new movie by creating a new project. The most important thing is to match your project settings to the format of the video resources you will be adding since you can't change the settings after you begin sequencing your movie.

Premiere Elements features a number of project Presets to simplify getting the settings right. You'll need to select a Preset (a DV camera format is the default) to match the specifications of your camera's video format. Once you select a Preset for your first project, Premiere Elements will use it for any future projects you create until you select another preset.

1 From the Welcome screen, click New Project.

Or

2 From within Premiere Elements, select File, New Project from the menu bar. The New Project dialogue will appear.

3 Enter a descriptive name for your project.

4 Select where to save your project file. It does not have to be in the same folder or on the same drive as your source files.

5 Click Change Settings.

6 Click DSLR, and click 1080p, 480p or 720p as needed to expand the section.

7 Click a Preset (e.g. DSLR 1080p24) to view its description.

8 When you find a Preset that matches your camera's format, click OK to close the Change Settings dialogue.

9 Click OK to complete the New Project dialogue.

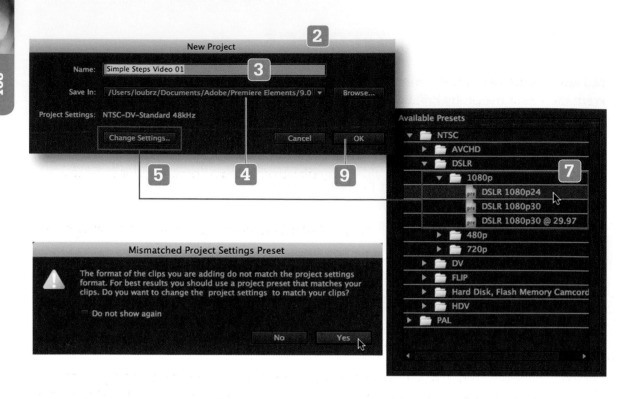

HOT TIP: If you can't find a Preset that precisely matches your camera, make your best guess or use the default. When you add your first clip to the Timeline or Sceneline, Premiere Elements will show an alert and offer to change the project settings to match your clips. Click Yes.

Get media

You use Get Media in the Organize tab to import movie-making assets into your Premiere Elements project. You can import silent video footage, movie clips (containing an audio track), still images (including raw files) and audio. As mentioned earlier, when you import, you're not actually bringing the files themselves into Premiere Elements. Instead, you're recording reference information that points to the files where they reside on your hard disk. Get Media can also copy files from media cards to your hard drive before adding them to your project.

1 Click the Organize tab and then click Get Media to open up the list of import options.

2 The Get Video from section includes Flip, AVCHD, Cameras and Phones. This allows you to copy files via a direct link to a camera or from a card reader.

3 The Get Photos from section allows you to import still images, including raw files. Click Digital Still Camera & Phones to activate Photo Downloader. Clicking the Get Media button in Photo Downloader adds them to your project.

4 The Get Videos/Photos/Audio from section allows you to link media that you have already transferred onto your hard disk. Click Files and Folders to open a dialogue to select files.

! ALERT: The Nikon D90 produces files in Motion JPEG format, which has a number of performance issues related to editing. Instead of editing the camera files, you should first convert them to a format called Prores 422. Prores is a high-quality format designed specifically for editing. You can use a free utility called MPEG Streamclip from Squared 5 to do the conversion. The software is available for both Mac and Windows. Visit www.squared5.com for more information.

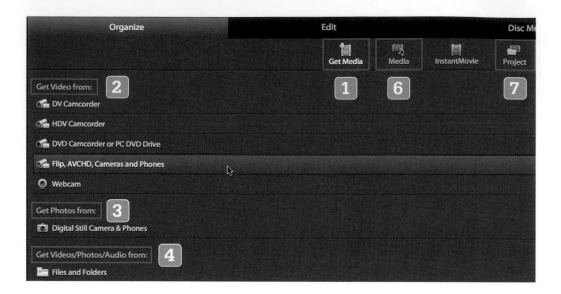

5 If any import dialogue you select has an option that says 'After Copying Delete Originals', avoid it. You should make a habit of erasing the card only after you have confirmed that the transfer has been successful.

6 After you use Get Media, Premiere Elements will switch to the Media filter in the Organize tab to show the most recently imported assets.

7 You can click on the Project filter at any time to see all files that you have imported into your project.

Arrange media on the Sceneline

You'll sequence the elements of your video project in the My Project panel, which features the Timeline and Sceneline tabs. Click the Sceneline tab to activate it.

The Sceneline is a simplified sequencing tool that is particularly useful for people who are new to editing. It works like a storyboard and is great for quickly and easily arranging assets, titles, transitions and effects. You can start assembling elements with the Sceneline, then switch to the Timeline to refine your edit. As you assemble your movie, you can switch back and forth between these two views at any time.

1 Activate the Organize tab, then click the Project view to see all assets that have been added to the current project, or click the Media view to see assets that were recently added to any project.

2 To add a clip to the Sceneline: Drag an asset to a blank box and release the mouse button when the cursor changes to the insert icon. Or drag an asset on top of a clip in the Sceneline to insert the new clip ahead of it.

3 Drag clips within the Sceneline to reorder them.

4 To remove a clip from the Sceneline: Click a box to select it and hit the Delete/ Backspace key.

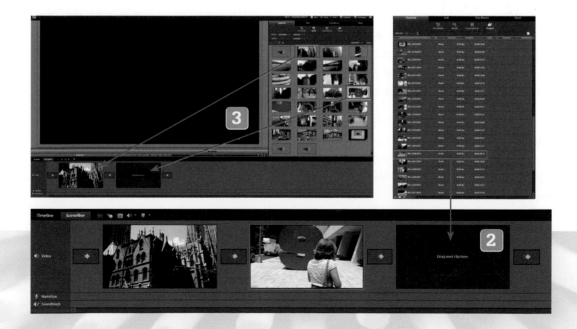

Arrange media on the Timeline

The Timeline offers a more detailed and precise view of the elements of your project and has advanced features for trimming and synchronising movie assets. That advanced functionality adds a bit of complexity to its use. Click the Timeline tab in the My Project panel to activate it.

While the Sceneline simply shows the structure of your project as fixed-size sequential boxes, the Timeline displays it as boxes on tracks that can be layered, where the width of each box represents the relative length of the clips. You can use the zoom control in the upper right corner of the Timeline to adjust the time scale. The boxes on the Timeline become wider or narrower accordingly.

In most cases, your camera footage will consist of linked audio and video tracks that normally move as a unit but can be split apart. You can butt clips together on a single video track, or you can stack them on separate tracks. And, if you run out of tracks, you can add more. The layers work much like layers in Photoshop, allowing you to create composite video effects such as still overlays or split-screens. As you move assets around the Timeline, there will be a number of situations where you'll be concerned with whether other assets shift with them or not, and there are a number of keystrokes to control that.

1 To add a clip to the Timeline: Drag media from the Project or Media views in the Organize tab to the Timeline. A vertical line will appear, showing where the clip will snap. Be sure to drag the very first video clip to the leftmost extreme of the Video 1 track. When you drag subsequent video clips to the Timeline, it's important to be sure that they snap to the end of the previous clip. Otherwise there will be gaps of video black between your clips.

2 To move a clip on the timeline: Activate the Selection tool (tap the V key) and drag the clip. When you move a clip between two others, the clips to the right will move over to allow room for the new clip. The default behaviour is to leave a gap in the Timeline where the clip has been. You can click to select the gap and hit the Delete/Backspace key to clear it.

3 Optional: If you want the gap to close automatically as you reposition the clip, hold down the Command/Ctrl key and start to drag the clip to its new location. Release the Command/Ctrl key before you release the mouse button to insert the clip into its new location.

4 Optional: To overlay a clip that you are moving (instead of inserting it between clips), drag the clip to its destination and press the Command/Ctrl key before you release the mouse button.

5 Optional: To insert the clip that you are dragging and shift only clips on the track that you are dragging the clip to, press the Option/Alt key before releasing the mouse button.

6 To delete a clip from the Timeline, click the clip with the Selection tool and hit the Delete/Backspace key. By default, the clips will slide to the left to close the gap.

7 Optional: To remove clips without closing the gap, click on the clip with the Selection tool and select Edit, Clear from the menu bar.

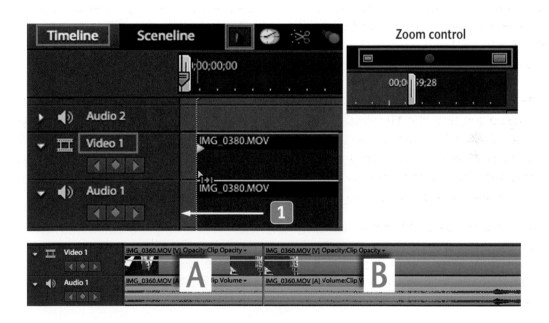

HOT TIP: It may take some time to get used to moving elements around the Timeline. Remember that you can always use Command/Ctrl + Z to step backwards and undo as many steps as you need.

Edit start and end points in the Sceneline

When you begin putting your movies together, you're likely to find that you want to remove extra footage at the beginning and end of your shots so that they transition better. Premiere Elements allows you to trim clips in a non-destructive way while previewing how your entire sequence of clips is coming together.

1 To begin trimming in the Sceneline, click on a clip to bring it up on the Monitor panel.

2 Drag the Current Time indicator at the bottom of the monitor panel to find the spot where the action begins or ends and leave it there as a place marker.

3 To trim the beginning of the clip, drag the In Point handle to the right. You can use the Current Time indicator to position the handle.

4 After trimming, the Current Time indicator will remain in place. Reposition it as needed to locate your next edit point.

5 To trim the end of the clip, drag the Out Point handle to the left. As you trim the In and Out Points, the view in the Monitor panel will split to show the transition to the adjacent clip.

6 To trim footage from the middle of a clip, you split the clip into two and adjust the new Out and In Points.

- Position the Current Time indicator at the point where you want to split the clip.
- Click the scissor icon in the lower right corner of the Monitor panel. The clip will split at the Current Time indicator.
- Use the Current Time indicator to determine where to place the In and Out Points of the resulting clips.

7 Optional: To restore trimmed footage, drag the In Point handle to the left and the Out Point handle to the right as needed.

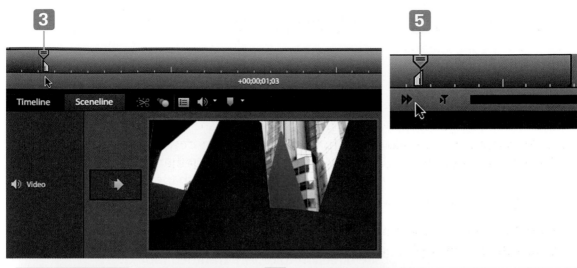

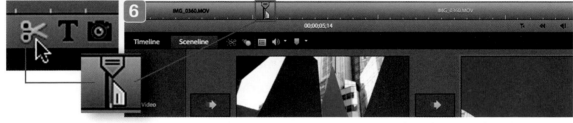

HOT TIP: Pro video shooters intentionally start their cameras rolling before the action begins and leave them running afterwards to create what are known as head and tail frames.

Edit start and end points in the Timeline

Trimming clips in the Timeline is slightly simpler and more direct than working with the Sceneline.

1 To begin editing the In Point or Out Point of a clip in the Timeline, position your cursor near the edge of the clip. The cursor will change shape to indicate that it is ready to trim the clip.

2 Drag the edge of the clip to the right or left towards the middle of the clip as needed.

3 Drag the edge in the opposite direction to restore trimmed footage.

4 To trim footage from the middle of a clip, split the clip into two and adjust the new Out and In Points as shown in steps 1–3.

- Position the Current Time indicator at the point where you want to split the clip.
- Click the scissor icon in the lower right corner of the Monitor panel. The clip will split at the Current Time indicator.
- Use the Current Time indicator to determine where to place the In and Out Points of the resulting clips.

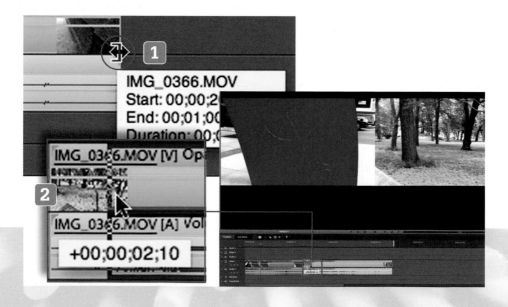

Add transitions

So far, you've seen how to create 'jump cuts' by butting clips together. Transitions are a way to let your viewers know that your scene is changing. They are often used to indicate that the time or location of the story is about to change. It's easy to apply transitions in Premiere Elements.

1. Click the Edit tab and then click the Transitions icon to show the available Transitions.

2. Click a Transition to see a preview of what it does. The A and B designations refer to the clips that the Transition sits between. The clip on the left is the A clip, and the clip on the right is the B clip.

3. To apply a Transition to the Sceneline, drag the Effects icon to one of the placeholders between clips or at the beginning or end of the movie. You can replace a Transition by dropping a new one over it.

4. To remove a Transition from the Sceneline, click the placeholder and hit the Delete/Backspace key.

5. To apply a Transition to the Timeline, drag the Transitions icon to the Timeline where two clips meet. The cursor will change shape to indicate that it is ready to place the Transition.

6. Position the Current Time indicator just before the Transition and use the Play/Pause toggle button in the Monitor panel to see your Transition in action.

7. Optional: Use the Zoom control to magnify the Timeline.

8. Optional: Drag the Transition box to the left or right to position it.

9. Optional: Drag the edges of the Transition to trim or expand its duration.

10. Optional: To replace a Transition, drag a different Transition to the box on the Timeline. The replacement will take on the adjusted size and position of its predecessor.

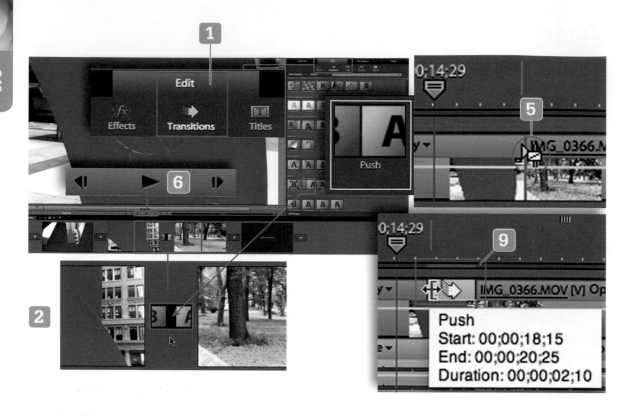

HOT TIP: To render a new preview, select Timeline, Render Work Area from the menu or hit Return/Enter on the keyboard. Rendering can take a while, depending upon the length and complexity of your project.

ALERT: Many effects and transitions require a lot of computing power to display. These can affect the playback in the Monitor panel, so Premiere Elements allows you to render previews that will play back correctly. If a thin red line appears just below the ruler markings in the Timeline, you'll want to render previews. After rendering, the line will turn green.

Apply effects

Premiere Elements Effects comprise an extremely broad category of functionality that can alter the appearance of your movie in many ways. You apply effects to individual clips and adjust their behaviour through controls in the Edit tab of the Tasks panel. The design of the effects ranges from simple to extremely complex, but the process of applying and adjusting them remains the same.

1 Click a clip in the Timeline or Sceneline to select it.

2 Click the Edit tab and then click Effects to bring up the effects list.

3 Optional: Type any part of the name of an effect in the search box to filter the list. Clear the field to remove the filter.

4 Optional: Click the eyeball icon at the right of the search field to use the current frame as a thumbnail. (This sometimes helps visualise how the effect works.)

5 To apply an effect, drag the effect icon from the Tasks panel to the clip on the Timeline or Sceneline.

6 To adjust the effect parameters, move the Current Time indicator so that the selected clip appears in the Monitor panel. Click Edit Effects at the bottom of the Tasks panel and adjust the controls as needed.

7 Variable effects such as Fade In and Fade Out are applied at different amounts on a frame-by-frame basis. Use the Show Keyframes and Hide Keyframes buttons to adjust controls for how the effects are applied.

8 If a red line appears at the top of your Timeline, be sure to hit Return/Enter to render the work area.

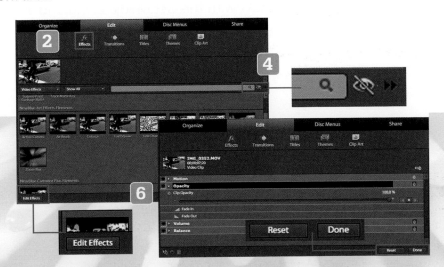

Add narration and sound

The two approaches for adding basic narration to your video are a) to pre-record audio clips that you assemble on the Timeline in the same fashion that you assemble video clips, or b) to play back your video and narrate directly onto the narration track in your project. Of course, you can combine the two techniques and add music tracks as well.

Every Premiere Elements project starts with two audio-only tracks labelled Narration and Soundtrack. If you use the option to record narration, your recording will appear in the Narration track first, but you can drag that audio to other tracks and set In and Out points just as you do with video tracks.

Chances are, the movie clips you began with have their own audio tracks. Rather than remove those tracks, you may want to reduce their volume and mix your narration and soundtrack elements with them. The Audio Mix window allows you to play back your movie and record the sound-level settings for each audio track as the movie plays.

1 To begin recording narration, click on the speaker icon at the top of the My Project panel and select Add Narration from the menu. Place the Current Time indicator where you want your narration to begin and click the Start/Stop Narration button. Press the button again when you've finished recording.

2 Set In and Out Points for your narration track in the same manner that you adjust video tracks.

3 If you don't like part of your narration, move the Current Time indicator to just before the problem part of your track and then use the scissor icon in the lower right corner of the Monitor panel to split the clip. You can then delete the part of the track you don't want.

4 Import any pre-recorded audio tracks with the Get Media command and place them on the Timeline. Edit In and Out points as needed.

5 To begin mixing your audio tracks, click the speaker icon and select Audio mix from the menu. Position the Current Time indicator where you want to begin recording your levels settings and click the Play button in the Monitor panel.

6 Adjust the sliders and tick the mute boxes in the Audio Mixer window as needed while the movie plays. You can stop the movie and move the Current Time indicator at any time. When you resume playback, you can continue to adjust the sound levels, overriding any settings you had recorded previously.

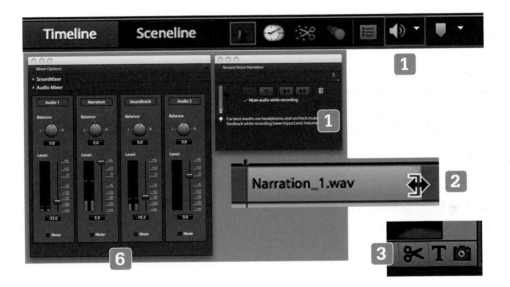

Add titles

Within Premiere Elements, there are three sets of tools for adding titles to your movie project. You'll probably use the Text tool on a regular basis to create simple static text titles at the beginning of your movie, or subtitles throughout. The tool is available via the T icon in the lower right corner of the Monitor panel. Beyond static text titles, you may want to add Rolls (text that moves vertically – often used for credits at the end) or Crawls (text that moves horizontally). Rolls and Crawls are available via the Title menu.

As you're laying out your titles, you'll see two rectangles superimposed over your work area. The inner rectangle is the 'title safe' area – you should design all of your titles to fit within that area if your movie will be shown on television. If you're composing for the Web or CD, it doesn't apply.

Once you design your titles, you can set In and Out Points as usual, and you can even apply effects such as Fade-Outs. In most cases you'll also need to render the work area (see page 178) before your preview will play correctly.

1. To place static text titles, position the Current Time marker where you want your titles to begin and click the T icon in the Monitor panel.

2. Use the icons in the upper right corner of the Monitor panel to select, move and edit text.

3. Click a block of text with the selection tool or highlight individual words to apply text styles to. Click on a text style to apply it or text options such as Font, Text Size and Kerning.

4. Click Done in the lower right corner of the Organize tab to finish your edit. The new title will appear as a video clip on your Timeline and as a still image in the Organize tab under the Project Filter.

5. Drag the edges of the title box in the Timeline to increase or decrease duration on screen.

6 Double-click the title box in the Timeline to edit again.

7 To place a Roll or Crawl, position the Current Time marker where you want your titles to begin and select Title, New Title, Default Roll or Title, New Title, Default Crawl from the menu bar.

8 Edit the text in the same fashion as in steps 2–6 above.

9 If a red line appears at the top of your Timeline, hit Return/Enter to render a new preview.

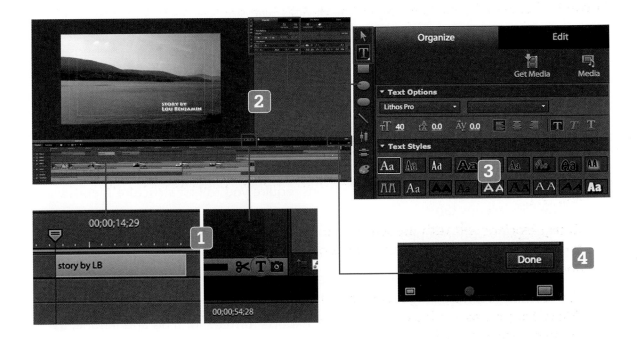

HOT TIP: If you click the Edit tab in the Tasks panel, you'll see the Titles button, which gives you access to stylised combinations of text and graphic elements. It might be best to refer to these as title templates. You're likely to use this feature the least because many of the designs may clash with the visual design of your movie.

Share your video

The export features in the Share tab of the Tasks panel can translate your finished movie into a broad range of formats, including various computer and DVD-style formats, as well as formats compatible with YouTube, iPhone, Sony PSP and even videotape. When you export files for sharing, Premiere Elements renders a formatted copy of your project and your original work remains untouched.

One of the great design features of Premiere Elements is that you can create and edit your project using extremely high-quality video source material. However, when it comes to sharing, movies of the same quality as your original source material are likely to be too much to handle for many of the devices, websites and media platforms you'll want to use to share them. The main thing to understand when exporting is the qualities, capabilities and limitations of the various video formats so you can choose the ones that are best for your purposes. With that knowledge, you're likely to find the available options in the Share tab to be abundantly useful.

1 Click the Share tab to begin your export and select the type of format you want to create.

- The web DVD and Online options automatically upload content to the Web.

- The DVD, Blu-ray and web DVD options require you to first structure menus via the Disc Menus tab.

- The Online option supports YouTube, Photoshop.com and Podbean (a web-hosting company).

- The Computer option allows you to create Flash, MPEG or small QuickTime videos that can be sent by email.

- The Mobile Phones and Players option exports formats for iPod and iPhone, as well as Sony PSP and audio-only podcasts in AAC audio for iPod or MP3.

2 Choose the location and settings. For example, if you're using the Computer option, you'll need to specify a format, file name and where the file will be saved. Use Next or Back buttons as needed to progress through any additional dialogues (the YouTube option has a login dialogue).

3 Premiere Elements will confirm when your export is complete.

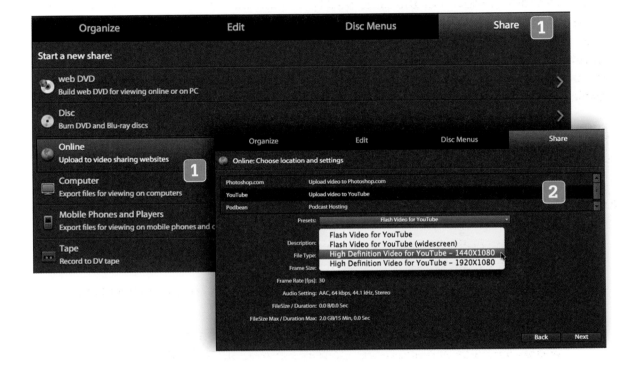

ALERT: Video files can easily become very large and there are also some formats that play only on specific platforms. For example, the FLV file format is popular but cannot play on iPhones or iPads. YouTube and smart phones work with much lower-resolution files than the raw footage that comes out of a 1080p dSLR, and many email providers have a file size limit that prevents you from attaching large videos.

Top 10 Digital SLR Problems Solved

Problem 1: My photos are noisy

If your photos are too noisy, it's because your ISO setting is too high. It's likely that you're using the high ISO to compensate for low light. Cropped-sensor cameras begin to have noise issues starting at about ISO 800. Full-frame cameras have a lot less noise at high ISO settings because their chips produce less noise.

Noise is part and parcel of digital photography. It increases as you increase the ISO setting on your camera because your camera raises its sensitivity by amplifying the signal from its sensor chip. As you turn up the 'volume' on the chip, the noise increases in the same way that it does when you turn up the volume on a sound system.

Here are some strategies for dealing with noise.

1. Reduce your ISO setting. You can compensate for the lower setting with a wider aperture, longer shutter speeds, or a combination of the two. Keep in mind that wider apertures produce shallower depth of field, and extremely fast lenses have a premium price tag. Exposures of 1/60s or slower will need some kind of stabilisation to avoid issues with blurring.

2. You may be able to satisfactorily remove a certain level of noise with the noise-reduction tools in software such as Lightroom.

3. Shoot some tests to determine the highest ISO setting with acceptable noise. Once you know that value, you can avoid higher ISO values.

4. If you use Auto-ISO (not recommended), set the controls so that it does not select settings higher than the level you determined in your test shots.

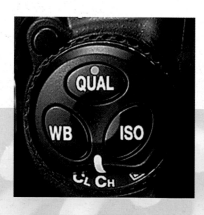

Problem 2: My night and indoor photos are blurry

The blur you're seeing is most probably produced by camera shake, or your subjects are moving. When you shoot in low light, your camera's light meter will select a slow shutter speed that makes it prone to motion-induced blurring.

1 You can increase ISO up to a point. Keep in mind that increasing ISO increases noise.

2 You can use a wider aperture. Each additional stop that you open the aperture means you can double the shutter speed to produce an equivalent exposure. So, if you open up from $f/5.6$ to $f/2.8$ (2 stops), your shutter speed can go from 1/30s to 1/125s.

3 A monopod is not as stable as a tripod, but it is easier to set up and manoeuvre. Both are better choices than hand-holding alone.

4 You can brace yourself against a wall, fence or other structure. Keeping your elbows close to your body will also help reduce shake.

5 VR and IS lenses can provide the effect of a shutter speed increase of 2 stops. That means your hand-held shots at 1/30s can look as though they were taken at 1/125s with a normal lens.

6 Use a hot-shoe flash that moves the flash away from the camera.

Problem 3: I want to avoid silhouettes

When strong light is coming from behind your subject, it can often influence your camera's light meter to reduce the exposure and throw them into silhouette. Once you're aware that the light is coming strongly from behind, you can compensate with a number of techniques.

1 Avoid backlighting when possible. For example, you may be able to turn your subject so that the light is coming from a side angle instead.

2 Open up the exposure. This will cause more of the strongly lit background to blow out, but it will also show more details in the shadow areas. Depending on the intensity of the light, you may need to overexpose by as little as 2/3 of a stop or as much as 2 stops. There are several ways to do that:

- Exposure compensation works with the Program, Aperture priority and Shutter priority modes. Just dial in the amount of exposure increase you'd like.

- In Manual mode, you can reduce the shutter speed or open the aperture so that the exposure display indicates that you are overexposing.

3 Use a reflector to bounce light onto the subject. Your reflector can be anything from a wall or a sheet to a commercial reflector designed for that purpose.

4 Use fill flash. This is one of the few situations in which a camera's pop-up flash may be sufficient. You have to find out how to set the flash to Fill Flash mode, which throws just enough light to reduce the shadows. Fill Flash is never the main light.

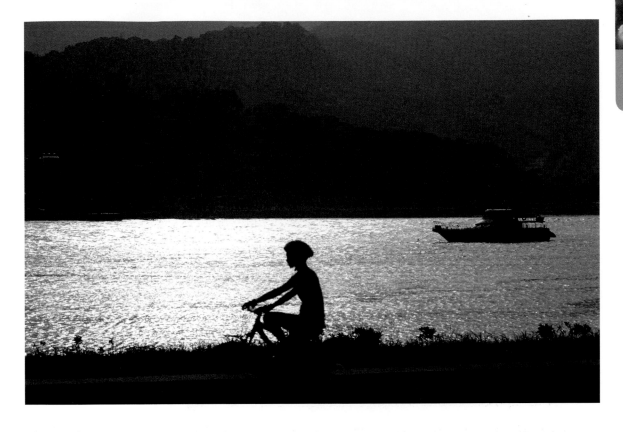

Problem 4: How do I deal with lens flare?

Lens flare is another problem that can occur when the light is coming from behind the subject. Extreme flare produces bright shapes in your image, and you'll typically see it happening in your viewfinder. However, a milder form of lens flare known as halation can cause your image to lose contrast before you see an actual flare.

If the light is travelling at an oblique angle, a lens shade can help. You can also 'flag' the lens with a hand, a notebook or some other opaque object – just be careful to keep your flag out of the shot.

Adding contrast in post-production can enhance images that are softened by halation. You can increase contrast globally, or paint contrast into selected parts of the image with tools such as the Adjustment brush in Lightroom.

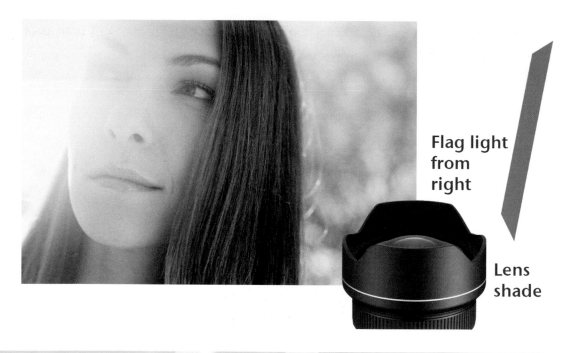

Flag light from right

Lens shade

Problem 5: How do I avoid red-eye?

Chapter 9 shows how you can edit out red-eye in Lightroom, but there are ways to shoot so that the problem doesn't occur in the first place.

Red-eye is probably the number one reason to avoid using your camera's pop-up flash. Light essentially travels in a straight line from the flash and reflects back into the lens from the subject's retina. All of this happens before the iris has time to close. The closer the flash is to the lens, the bigger the problem. When the flash is raised just a few inches above or to the side, the path of the light no longer bounces into the camera. The illustration shows an SB-900 flash mounted on a Nikon D700.

- The head of a hot-shoe flash (also known as a speedlight) such as the Canon 430EX or the Nikon SB-600 stands away from the camera body, significantly reducing the chance of red-eye.

- You can also tilt the head of many clip-on flash units to bounce the light onto your subject. The resulting indirect light eliminates red-eye.

Problem 6: Can I make flash shots look less 'flashy'?

Flash units often work too hard and put out too much light. Their bright, direct light can make your shots look harsh and flat, but that doesn't have to be the case. Smart TTL flash units such as the Canon 580EX and the Nikon SB-700 use the camera's metering system to determine their output level and can be controlled via the camera.

1 TTL systems have a flash-compensation control that works like exposure compensation. If your flash is too 'hot', you can dial in a negative value to reduce the output of the flash.

2 A number of attachments for bouncing and diffusing light are available for flashguns. Diffused and bounced light can significantly reduce the harshness of shadows with flash. The attachments also absorb light energy, which can end up causing your photos to look underexposed. You can use flash compensation to increase the output of your flash a bit.

HOT TIP: It takes more work with older-style auto-flash units that don't talk to the camera, but they, too, can be tamed. You can enter a higher ISO number to decrease its output.

Problem 7: My prints look dark

When you look at a print, light is being absorbed by the paper and ink, and a certain amount bounces back to your eyes. The brightest parts of the print can only be as bright as the paper itself. When you look at an image on a computer screen, light is shining directly into your eyes, and the light sources inside computer screens are many times brighter than the brightest paper available. So, if you're editing your images on a screen at full brightness, your prints are going to look considerably darker.

The solution is to reduce the brightness of your screen. It's a good idea to use a profiling and calibration tool such as the i1 Display 2 or ColorMunki to ensure that you're seeing colour as accurately as possible, and the software for these tools also guides you in setting the brightness of your screen. Computer screens are often capable of producing 300 candelas or more, and you should set your screen to somewhere in the range of 100 candelas.

That will bring the screen's brightness more in line with your prints. When you want to compare your prints to what's on screen, you'll still want to review the print under a light source and then look at the image on screen. If you hold up the print next to the screen, it will still be at a disadvantage because it's not likely to be well lit.

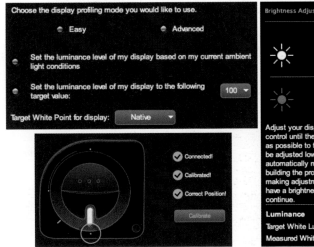

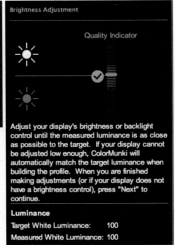

Problem 8: My prints are coming out with a magenta cast

One of the most common causes of this is having both your image-editing software and your printer driver managing colours.

1 If you set Photoshop, Elements, Lightroom, etc. to manage colours using a paper profile, make sure you turn off colour management in the printer.

2 If the colour performance with the colour profile you are using is not very good, it may be because the profile is inaccurate. Try setting the output colour space to sRGB and ignore the reminder to switch off the printer's colour management.

3 If you can't find the option to switch off the printer's colour management, try printing to sRGB from Lightroom or Photoshop and let the printer driver manage colours.

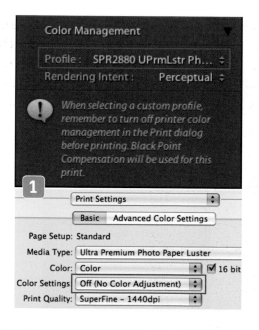
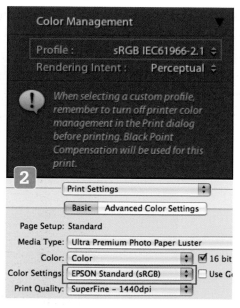

Problem 9: I'm having issues with file numbering on my photos

In Chapter 2, we looked at image naming and saw that the file name has two parts – a three-letter prefix that you can modify and a four-digit sequence number. To make your file names more manageable and avoid duplicate names, it's best to have your camera keep counting up from 0001 to 9999 and then gracefully start over with a new prefix. Depending on the make and model of your camera, file numbering may be handled in a number of ways.

- Nikon cameras: You have to switch the File number sequence feature to ON. Otherwise the camera starts numbering from 0001 each time you insert a new card. The option is located in the Custom Settings, CSM or Setup menu. On the D90, it's under submenu d, Shooting/display.

- Canon 550D: The default numbering option is called 'Continuous', which numbers images from 0001 to 9999 automatically. One exception is if you insert a card that already contains images – if the highest file number on the card is higher than the number in the camera's memory, the numbering will continue from the number on the card instead of on the camera. This is important if your numbering recently started over. It's best to reformat your memory card before you start shooting.

d Shooting/display

d1 Beep
d2 Viewfinder grid display
d3 ISO display and adjustment
d4 Viewfinder warning display
d5 Screen tips
d6 CL mode shooting speed
d7 File number sequence
d8 Shooting info display

*Example menu items
from Nikon D90*

Problem 10: I'm getting a message about an embedded profile mismatch in Photoshop

In Photoshop, whenever you open a file that has an embedded profile that does not match the working space and the Ask When Opening option is ticked for profile mismatches, you will see the Embedded Profile Mismatch dialogue. One situation where this can happen is if you set the colour space in Lightroom's External Editing preference to ProPhoto RGB, while the working RGB colour space in Photoshop is Adobe RGB.

The choice you're being asked to make is whether you want to work in the colour space that the image defines, or whether you want to convert the colours to the working space. Using the embedded profile is generally the best approach, especially if you plan to convert to another colour space after you've finished editing, since each time you convert colours there is a chance you will get colour shifts.

If you choose to convert the colours, there is less of a downside when you convert to a larger colour space, i.e. from sRGB to Adobe RGB or from Adobe RGB to ProPhoto RGB. Converting to a smaller colour space is more likely to degrade your image. The most problematic conversion would be to go from ProPhoto RGB to sRGB.

- In Photoshop: Select Edit, Color Settings from the menu bar to adjust the RGB working space.
- In Lightroom: Select Lightroom, Preferences (Windows: Edit, Preferences) from the menu bar to open the Preferences dialogue and then click on External Editing in the navigation bar at the top of the dialogue to change the colour space preference.

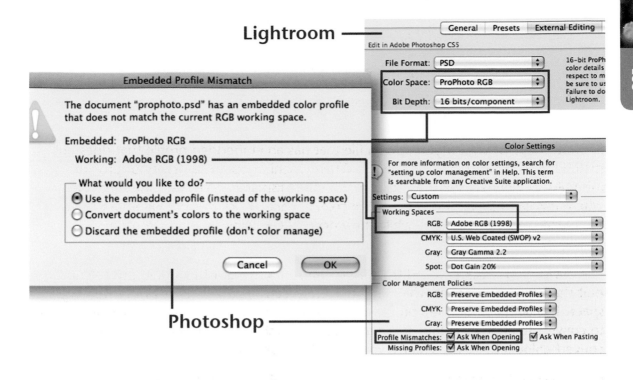

ALERT: If your image is in sRGB and you plan to adjust colours or tones significantly, there is some benefit to upgrading the colour space to Adobe RGB. If you're editing in ProPhoto RGB, it is critical that you stay in 16-bit mode throughout the process. If you encounter performance issues and want to switch to 8-bit mode, convert the colours to Adobe RGB before you change the image mode.

Also available in the In Simple Steps series

9780273736806

9780273745419

9780273729136

9780273744146

9780273736820

9780273746362

9780273762591

9780273723516

9780273761099

9780273761068

9780273744139

9780273761082

in Simple steps